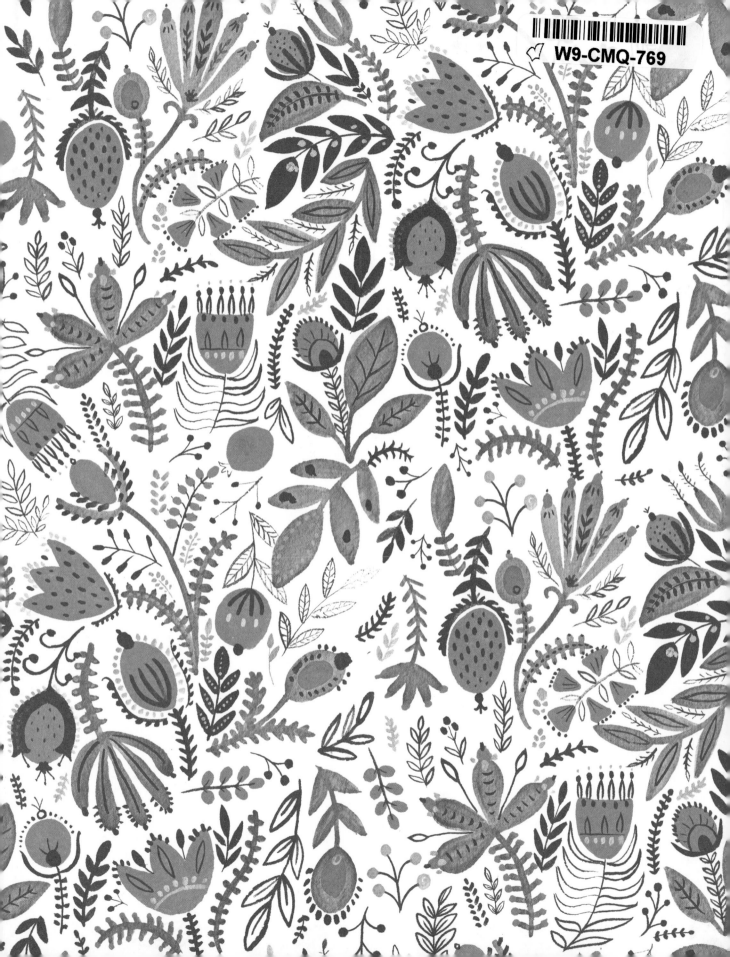

W9-CMQ-769

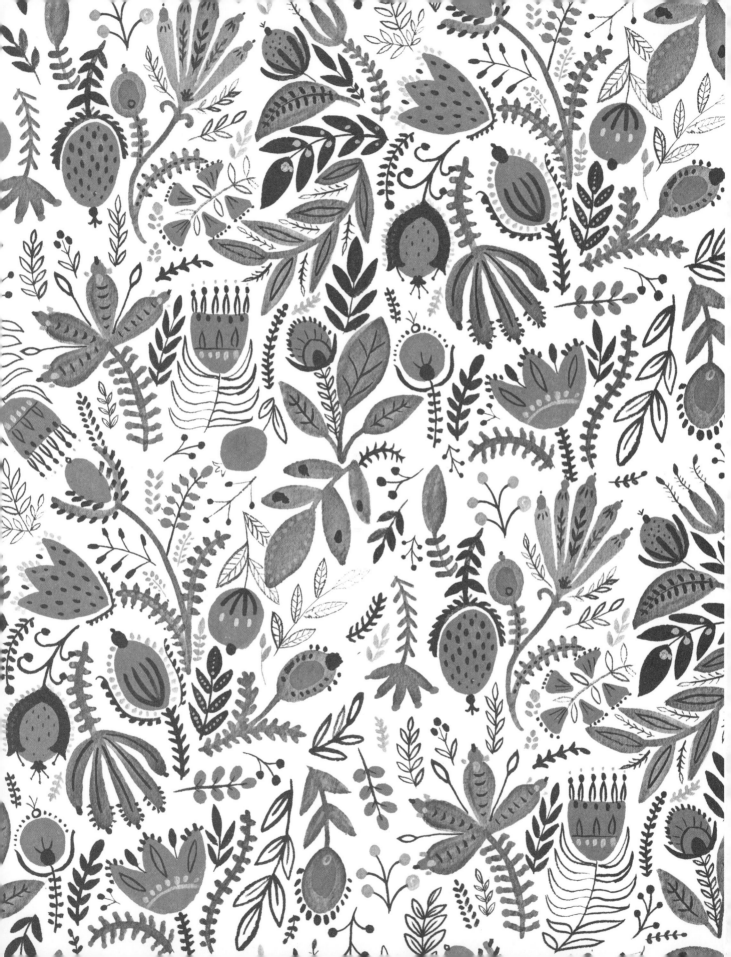

IMAGINE a FOREST

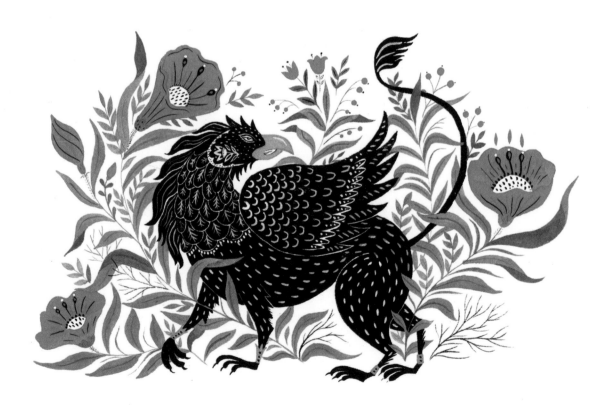

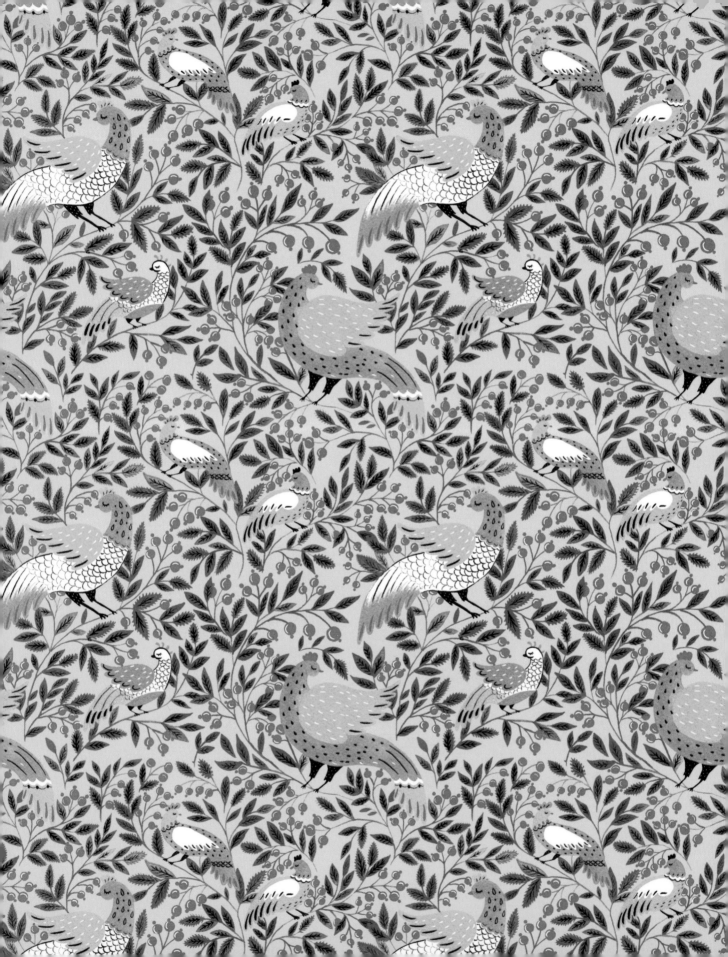

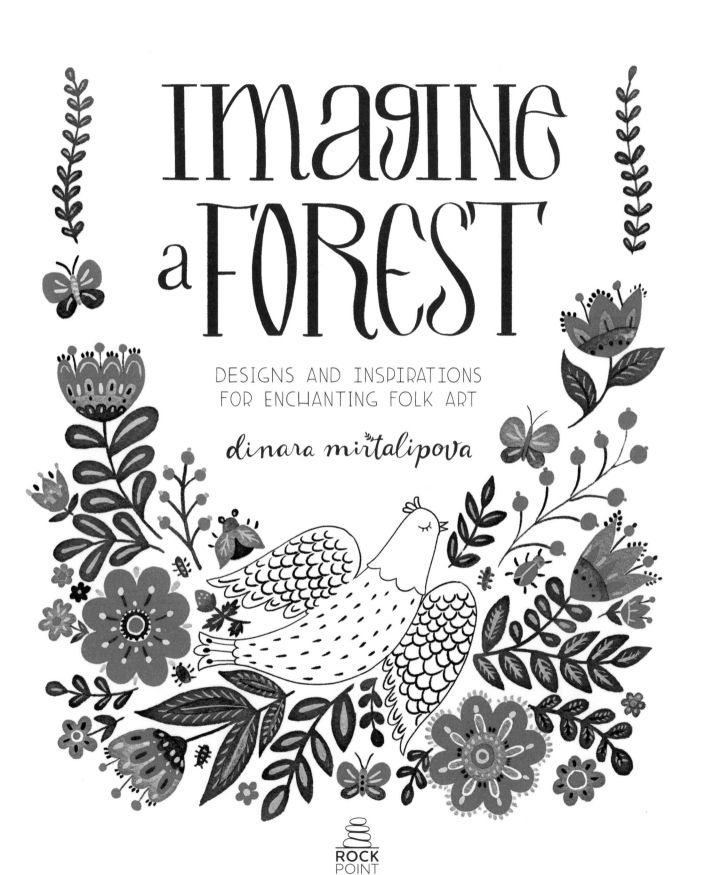

IMAGINE a FOREST

DESIGNS AND INSPIRATIONS
FOR ENCHANTING FOLK ART

dinara mirtalipova

ROCK POINT

Quarto is the authority on a wide range of topics.

Quarto educates, entertains and enriches the lives of our readers—enthusiasts and lovers of hands-on living.

www.quartoknows.com

© 2017 Quarto Publishing Group USA Inc.

First published in the United States of America in 2017 by
Rock Point Gift & Stationery, a member of
Quarto Publishing Group USA Inc.
142 West 36th Street, 4th Floor
New York, New York 10018
www.quartoknows.com

All rights reserved. No part of this book may be reproduced in any form without written permission of the copyright owners. All images in this book have been reproduced with the knowledge and prior consent of the artists concerned, and no responsibility is accepted by producer, publisher, or printer for any infringement of copyright or otherwise, arising from the contents of this publication. Every effort has been made to ensure that credits accurately comply with information supplied. We apologize for any inaccuracies that may have occurred and will resolve inaccurate or missing information in a subsequent reprinting of the book.

Photographs on page 99 used with permission from Ivan Hafiz

10 9 8 7 6 5 4 3 2

ISBN 978-1-63106-235-3

Interior Design: Tara Long

Printed in China

MIX
Paper from
responsible sources
FSC® C016973

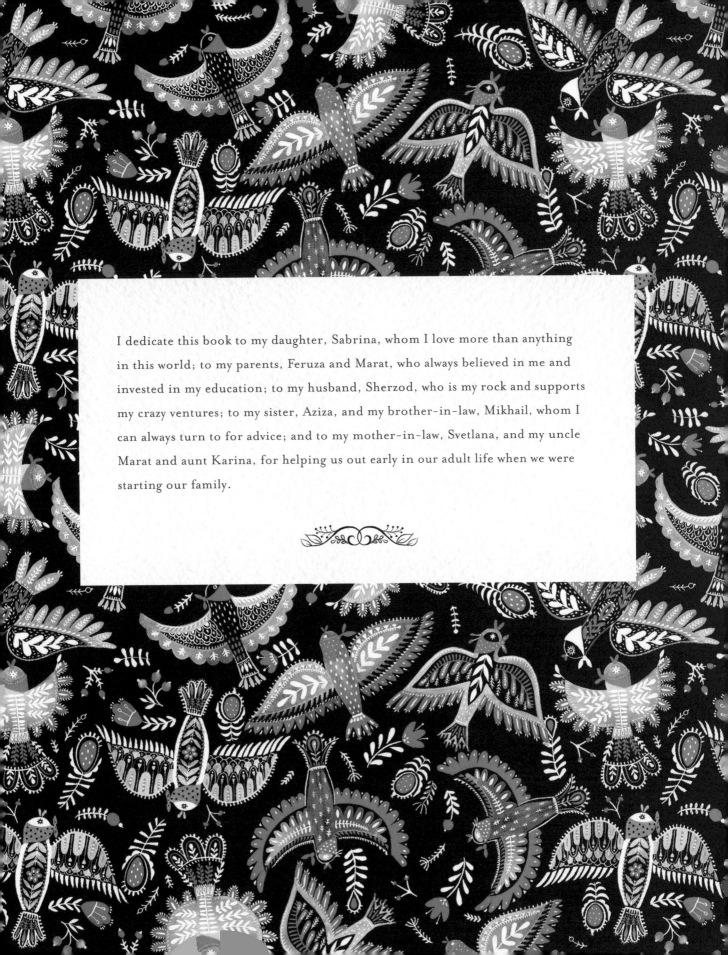

I dedicate this book to my daughter, Sabrina, whom I love more than anything in this world; to my parents, Feruza and Marat, who always believed in me and invested in my education; to my husband, Sherzod, who is my rock and supports my crazy ventures; to my sister, Aziza, and my brother-in-law, Mikhail, whom I can always turn to for advice; and to my mother-in-law, Svetlana, and my uncle Marat and aunt Karina, for helping us out early in our adult life when we were starting our family.

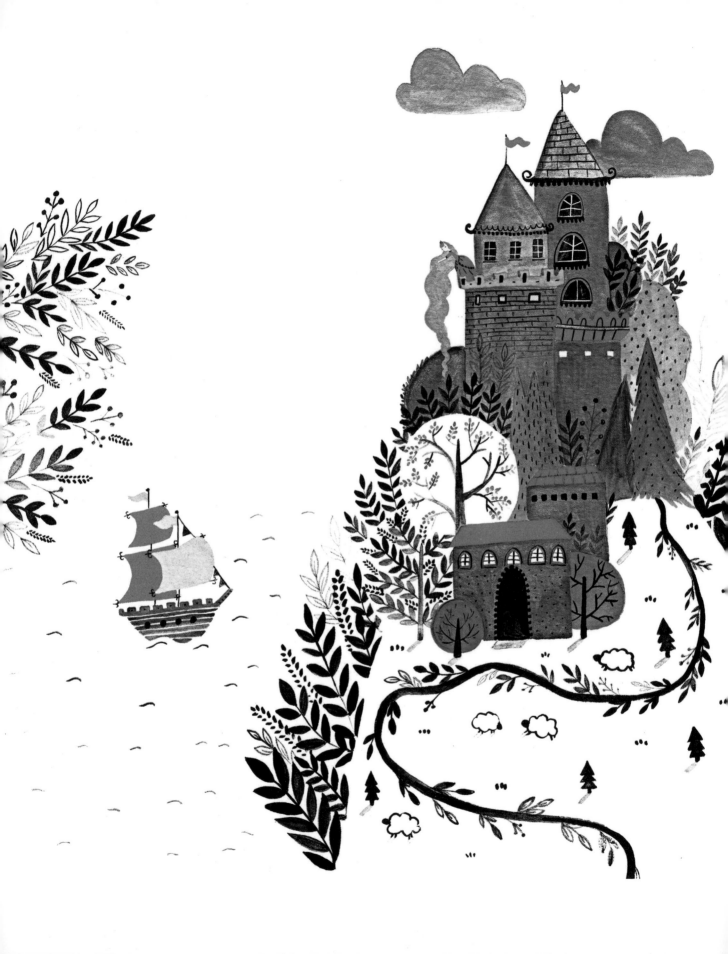

Contents

Introduction

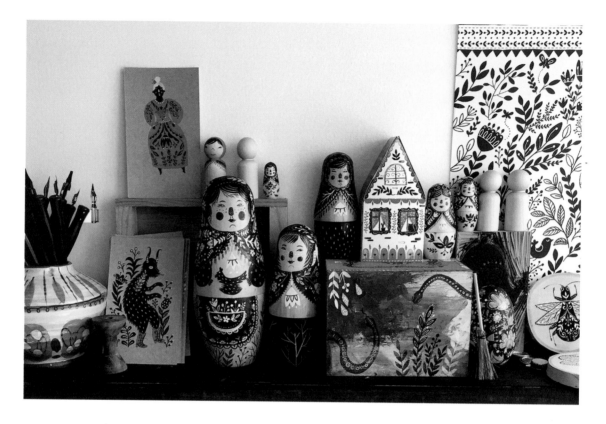

I COME FROM a family where arts and crafts were celebrated, but mostly as a part of everyday life rather than as an occupation. My mom has always been crafty, enjoying her embroidery in the evenings after coming home from work. I discovered the comfort of doodling and drawing at an early age and it occupied me throughout my school years, when I sketched in the back of every textbook and notebook I had. When it was time to select a college, I never considered art as a possible career path; instead, I wanted to go into a profession that I thought was more practical and that would pay my bills and support my family. So, I studied computer science and cybernetics, and learned all about coding and computer languages.

Right after graduation, my family and I found ourselves in the United States. The first few years were pretty difficult as we settled down in a new place. My first job was as a housekeeper at a small hotel by an airport, scrubbing toilets and cleaning rooms. Later, I found myself at the American Greetings headquarters in a part-time, second-shift, entry-level position that required very minimal skills, such as an ability to use scissors to cut out templates for their product mock-ups. My desire to escape scrubbing toilets was so great that I eagerly agreed to this new job. As soon as I entered the doors of American Greetings HQ, it was as if the golden gates of a creative world opened up in front of me. I knew right away that this was my calling and that I would never leave the world of creative arts.

I couldn't afford going back to school to pursue another degree in art, but I was very willing to dig up books in libraries and watch

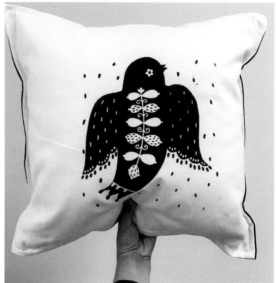

YouTube videos where people shared their knowledge about using design software programs like Illustrator, Photoshop, and InDesign. I spent many years practicing and building portfolio after portfolio. Eventually, I was hired at American Greetings as an in-house artist in a salaried position, where I worked on illustrating cards. I did that for many years. Then, I had my daughter Sabrina and she rocked my world. She was a baby who never slept and refused to take a bottle. I had a hard time leaving her and missed her terribly while away at work. I knew that it was time for me to leave my job and start a new chapter.

In 2014, I established myself as a freelance artist, working from my home studio. I was very nervous in the beginning because there was a lot of uncertainty. But everything worked out and my positive attitude paid off. I'm very lucky to be able to work with many great brands and to illustrate books and book covers, design fabrics, and collaborate on many interesting campaigns. My client list grew as my artistic style evolved. There's no better compliment than knowing that your art is appreciated! I'm happy to be at that stage where I can share my knowledge with others and, perhaps, inspire someone who is just starting out as I did years ago. People often

ask me what I do when I'm not drawing for my job. In my spare time, I love experimenting with new techniques, such as carving rubber stamps, silk-screening, and painting on wood. I find my inspiration in old movies, fairy tales that I read to my daughter, museum exhibits, and music. I'm discovering the world again with my daughter and learning along with her. It's as if I'm reliving my childhood by seeing the world through her eyes.

In this book, I show my way of drawing and painting. Because I'm a self-taught artist, my proportions are often exaggerated, but I believe art is not about precise details but ultimately about expression, or a story you're telling through your work and the emotions you're sharing. Painting with my daughter is wonderful, as she often reminds me that following rules is boring and insists on drawing things her way. So please look at the lessons I share here as an inspiration and try to discover your own way of drawing. I hope you enjoy this book as much as I enjoyed putting it together, and have fun with it!

Dinara

Tools

THERE ARE MANY GREAT TOOLS TO HAVE FUN WITH!
It took me years to narrow them down to a few that I use often. Go out and experiment as much as you can before you settle on your favorites.

BRUSHES

I'm a small-scale artist and my work tends to be very detailed and intricate; therefore, I prefer brushes in sizes 000 to 2 for all the decorative elements. I know many great artists who use inexpensive brushes and their work is still stunning, but in my experience, I find it irritating to use poor-quality brushes because they often have one or two hairs sticking out that can ruin a painting. It's a personal choice whether to invest in brand-name brushes, such as Winsor & Newton, or to purchase inexpensive ones and change them often. When it comes to painting a background, I simply use any 1- or 2-inch (2.5 or 5 cm) construction brush.

CALLIGRAPHY NIBS

These nibs are great for tiny, precise details. A Gillott 290 nib is just perfect.

PAINTS

Over the years, I have experimented with all kinds of paints, including oils, watercolors, pastels, acrylics, and gouache, my favorite. Gouache is a water-based paint—very mixable and very forgiving. I like it because it gives me the opaque quality that I'm looking for. The pros: if you happen to make a mistake on the paper, you can just paint over it, and if you have some paints left on your palette, you can still use it the next day, or days after. The cons: Because it's a water-based paint, you can use it only on paper. If used on any other surface, it will simply wash off. It dries fairy quickly, which can be inconvenient if you are painting larger surfaces, such as a background.

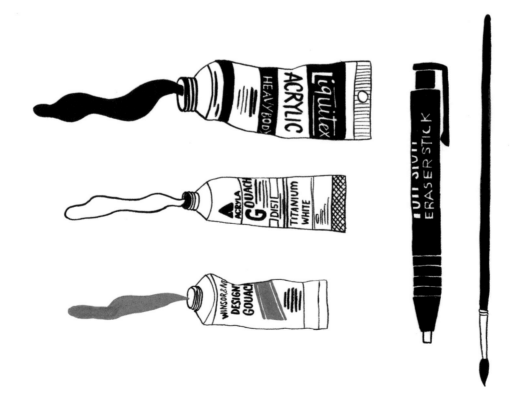

I use acrylics for painting on wood, because they are water-resistant and adhere to the surface much longer. Acrylics also dry quickly, and they can ruin your brushes if not washed off right away. Therefore, when painting with acrylics, I usually use less-expensive brushes. Once acrylic paint dries, it becomes plastic, and you won't be able to reuse the leftovers. I also wait for it to dry completely and then scrub it off of my palette and toss the remnants in the garbage, rather than rinsing it down the sink. Although it's not considered toxic, I still prefer not to let it go down the drain.

Recently, I discovered a paint called acryla gouache. It's a combination of acrylics and gouache. It has a chalky look, lies great on paper, and is moderately opaque and thick; but it dries like acrylics and can't be reused once it hardens.

INKS

I like using black ink for any black-and-white art. My favorite is Summa ink. It's thick and opaque, and it smells wonderful. It gives that pure, rich black line.

PAPER

I'm very specific about paper. I like when it's thick and can handle water on its surface. For my personal work, I prefer cold press paper because it has more texture. Artwork on cold press looks terrific when framed, and the texture is more noticeable in gallery lighting. I also like cotton handmade paper because it's very rough, and that's what makes it enjoyable to work with.

For jobs that require any technical alterations, such as color separation or digital manipulations, I use hot press, which is smooth. Artwork on hot press scans a lot better, which makes all the tweaking and retouching in Photoshop much simpler.

~ Color Palette ~

A color palette is a very personal choice. The easiest way to learn about your own color palette is to look in your closet. Your musical preferences also tell you a lot about your color palette. Your palette may shift over the years, just as your tastes change, and that is fine. The world of fashion is a significant influence in dictating which colors are popular and trendy each year, but chasing the trends is like chasing windmills. You will be at peace with yourself once you figure out which palette is truly yours.

I would describe my palette as earthy, grounded, and ashy, with a pop of bright orange or yellow. There are days when I gravitate more toward the green tones, and then there are times when I like the folksy combination of electric blue with tangerine. The classic black and white is my all-time favorite.

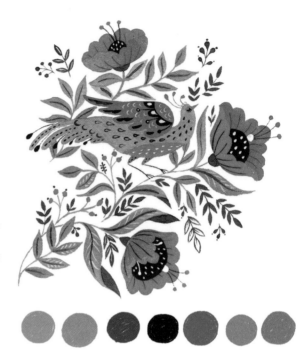

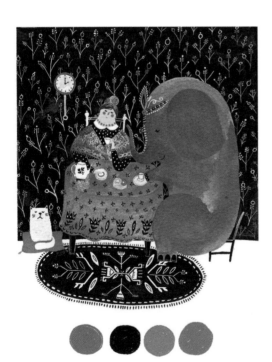

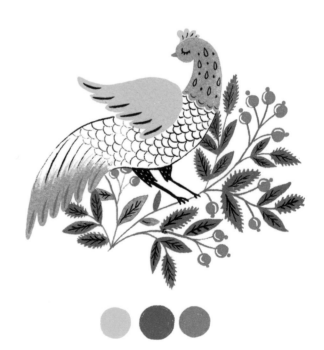

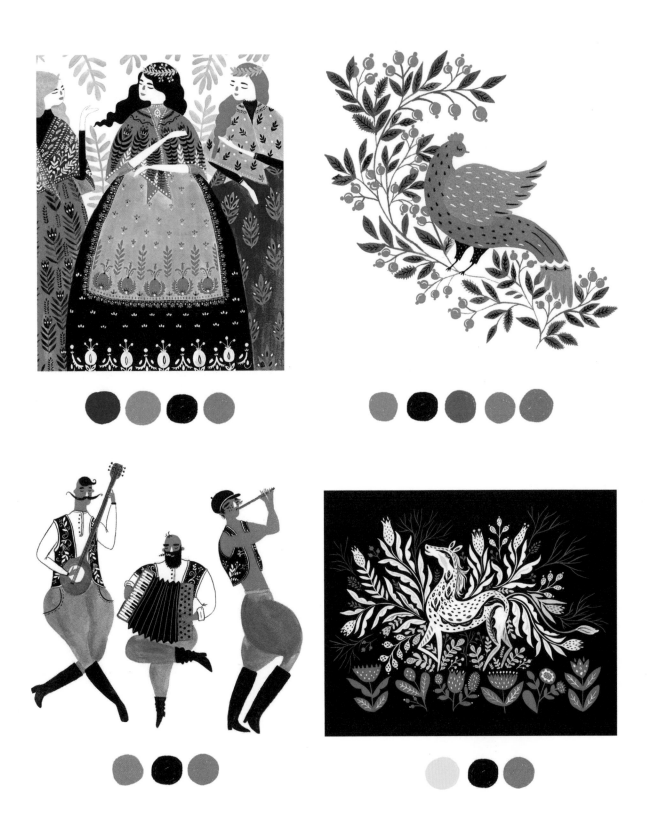

FLOWERS, FOliage + INSECTS

I REMEMBER WHEN I WAS LITTLE, my mom used to enjoy doing embroidery in the evenings after work. She was very patient, and her embroidery work was delicate and detailed. It usually took countless hours and many sleepless nights for her to complete a single work.

This was a time when there weren't many fashionable dresses available in stores, and women, like my mom, had to learn to sew for themselves. She made dresses for my little sister and me, and she loved decorating them with embroidered flowers and other design elements. She encouraged me to come up with motifs for her embroidery, and I was happy to draw a dozen flower patterns with different interpretations of each.

Today, I still love to draw flower motifs; only now, I like to imagine them decorating the dresses of my little girl. What's fun about drawing folk flowers is that the variations are endless: two petals, three petals, six petals; a single leaf or clusters; pistils or stamens; and of course, the colors! Adding small lines evokes stitching, making these flowers a loving tribute to my mom's treasured and skillful embroidery.

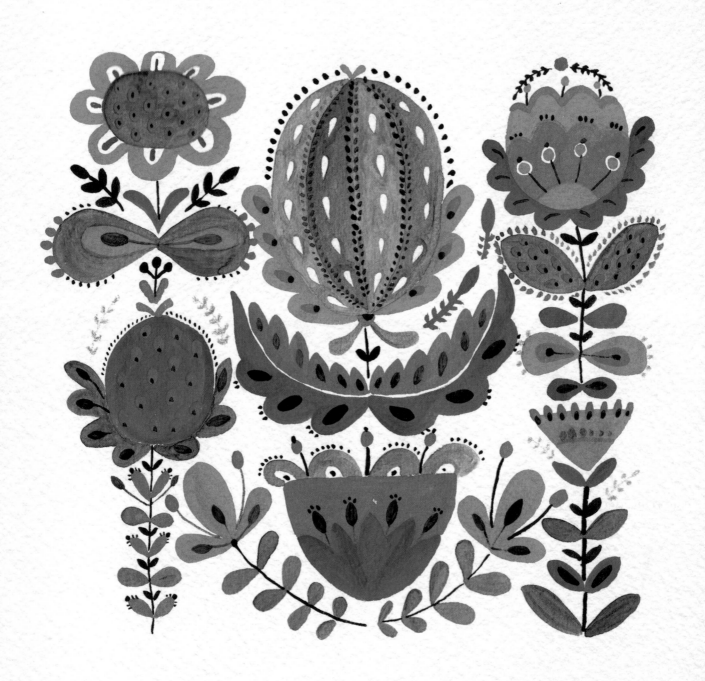

SINGLE FLOWER

When I draw a flower, I typically start with a circle or an oval. To simplify the shape in this exercise, make it symmetrical. Roughly sketch out a few details and decorations around your basic shape. Add another layer of details, so you know where to fill in. When it comes to painting the details, you can paint the background layer first and add details on top, or you can go around the mapped areas. Both ways are fine.

WILDFLOWERS

Sometimes I like drawing shapes that flow more organically. There's no symmetry in these shapes, which makes them more lyrical. Start with a curved line and add branches and leaves as you go. If you feel there's empty space between the branches, add a few loose elements to help fill it in. I like painting the leaves first, as it helps me visualize the balance in flowers. If needed, I can add more flowers as I go. I start with a limited palette and add colors as I work. Adding a few black elements provides contrast and makes the overall palette pop.

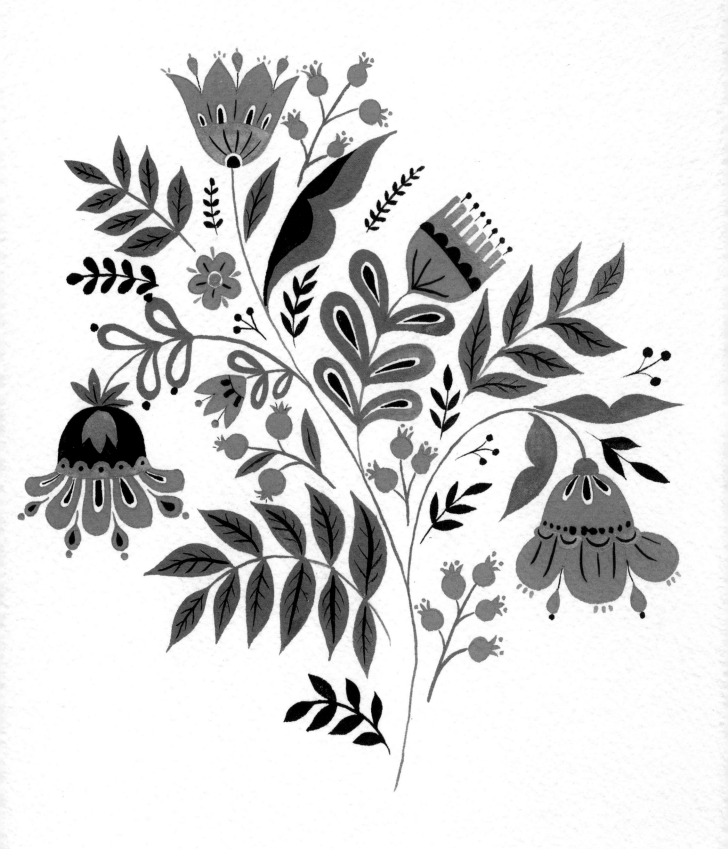

BOTANICAL COMPOSITION 1

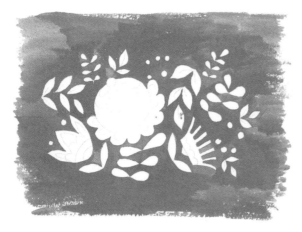
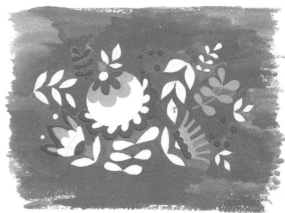
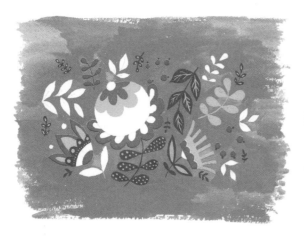
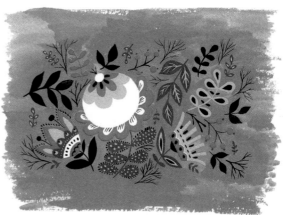

Here's an example of a composition with a painted background. I start with a light pencil sketch just to map out the main objects. Then, I paint the background. You can either cover the entire area with paint and wait a few minutes for it to dry completely and then draw your elements on top, or you can go around with your brush, leaving white spaces for your flowers, as shown in this example. I personally like the texture it creates when I go around with my brush. If you aim for a more even background, I suggest thickening your paints or painting a few coats. Next, start painting the flowers, keeping in mind color balance and making sure a consistent amount of the color is used throughout the painting. I gradually add tones: I start with the main colors and finish with subtle shades. Tiny details and intricate decorations come next. Dots and strokes are the easiest decorations and add another layer of visual complexity. Black usually goes last, but again, that's my personal preference.

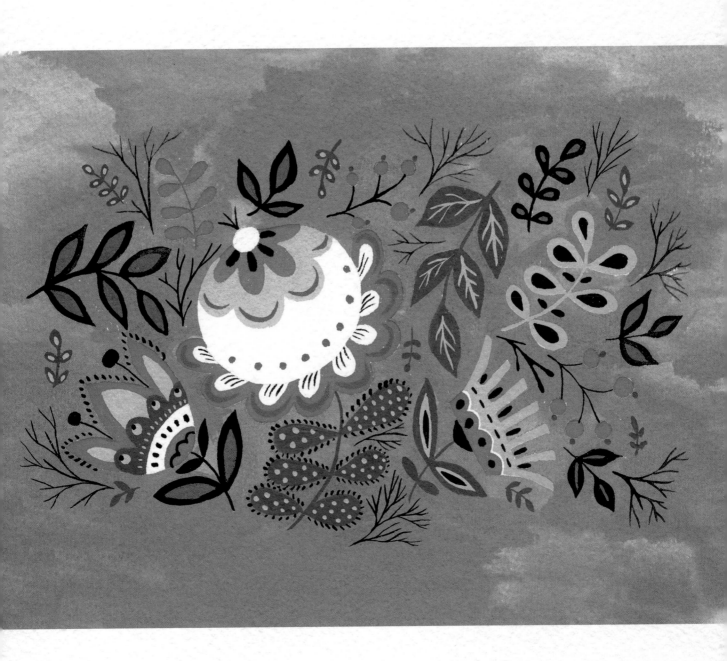

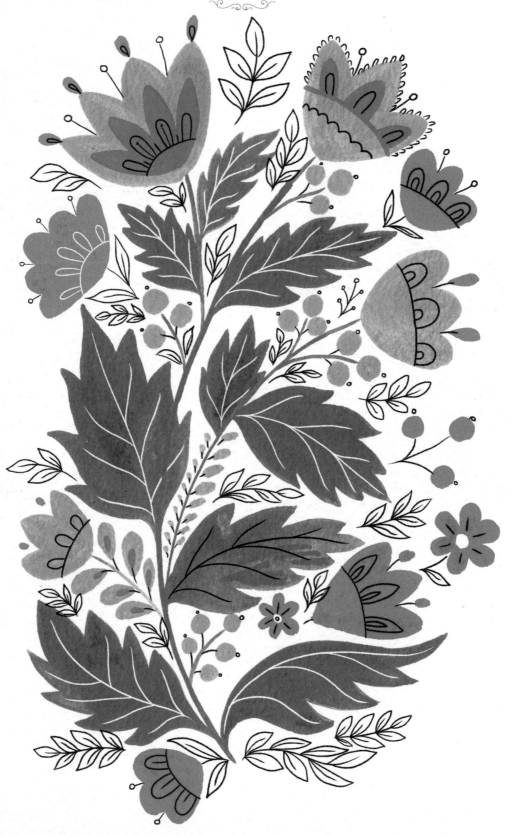

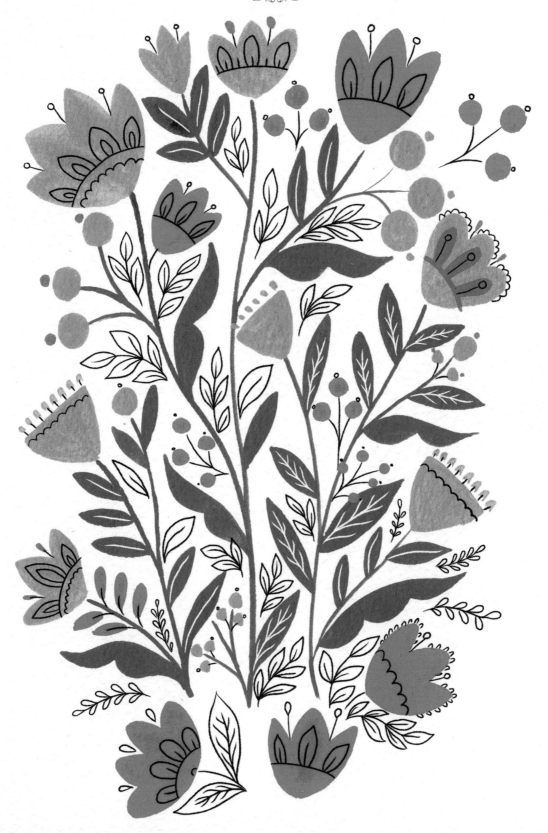

FLOWER VARIATION 1

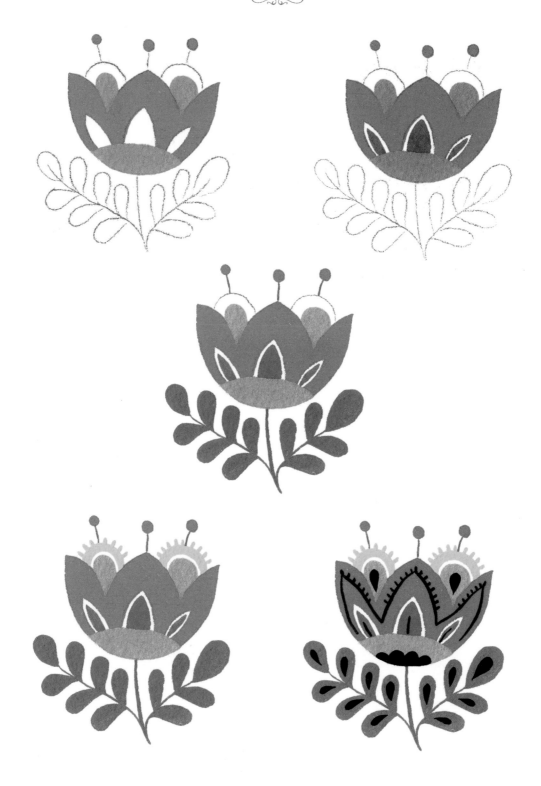

FLOWER VARIATION 2

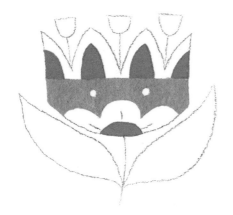

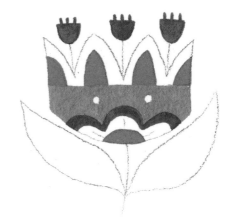

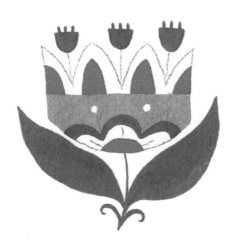

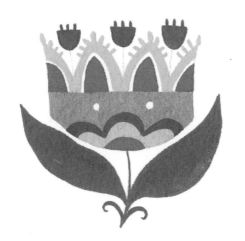

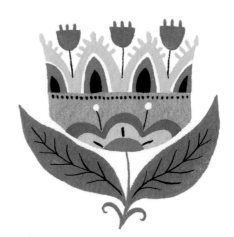

FLOWER VARIATION 3

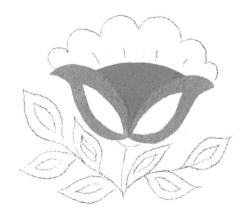
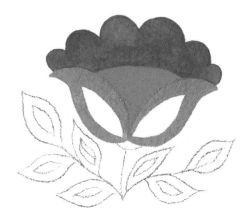
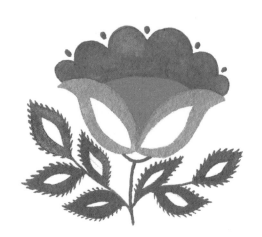
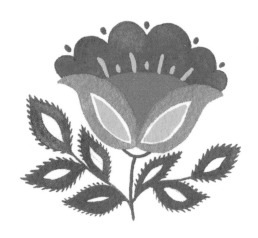
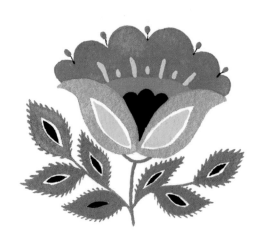

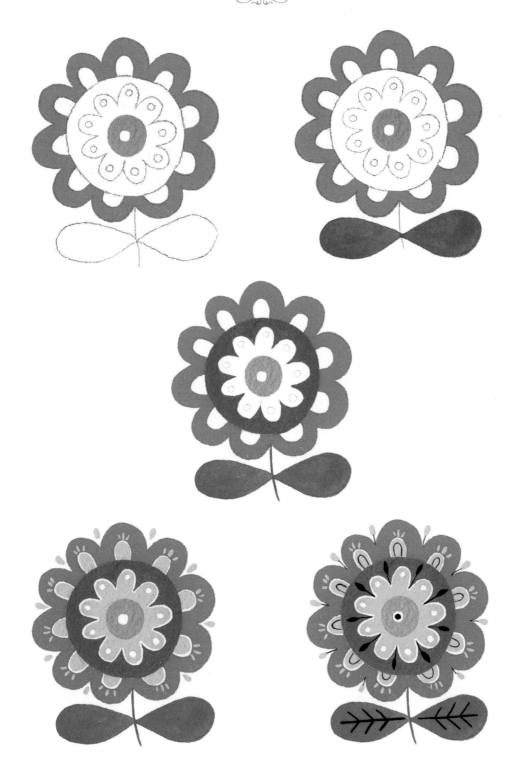

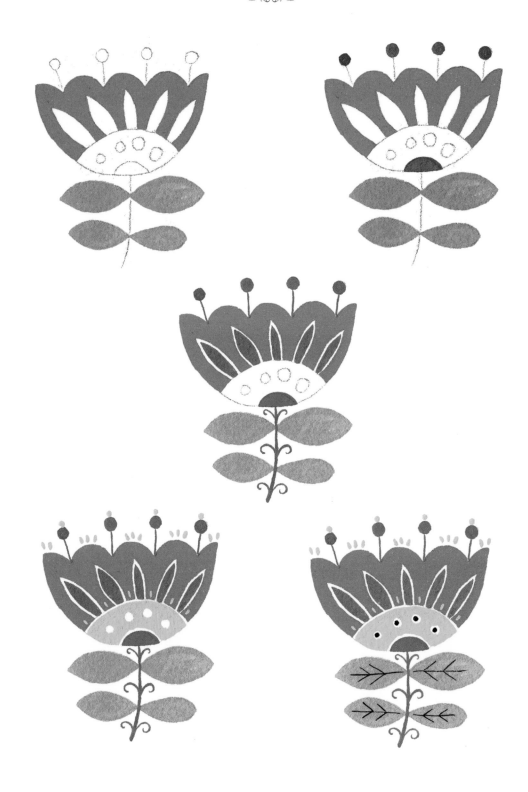

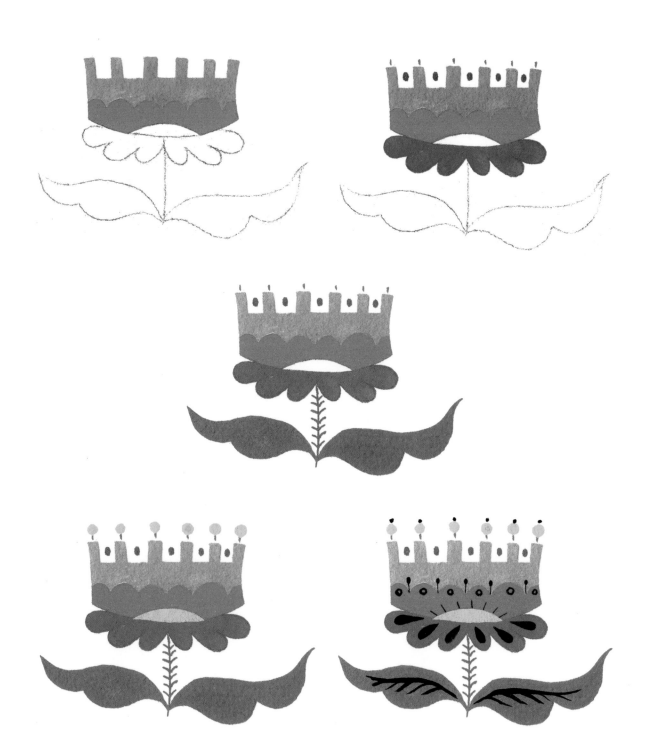

TREES

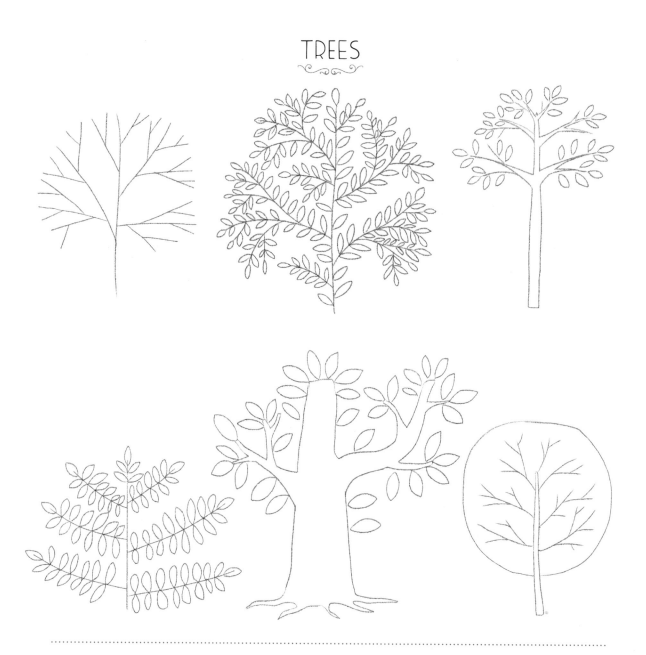

In folklore, trees are powerful symbols. Folk-style tree artwork is often connected with the calendar and the cycle of life. Trees are a way of illustrating different moments—bright, leafy trees for renewal and rebirth, autumnal leaves for harvest and abundance and barren of leaves and birds for stillness and reflection.

Here, I have rendered a variety of trees in different shapes and with different leaf types. So much of the tradition of drawing in the folkloric tradition starts with imagining a forest of trees. Look closely at all the beautiful trees in the forest. Pay close attention to the shapes of the branches, bark, and leaves. Following these steps will enable you to capture the natural beauty and magnificence of trees.

A tree can be the main focus of your composition or serve to create a setting for charming animals or a knight galloping on his horse.

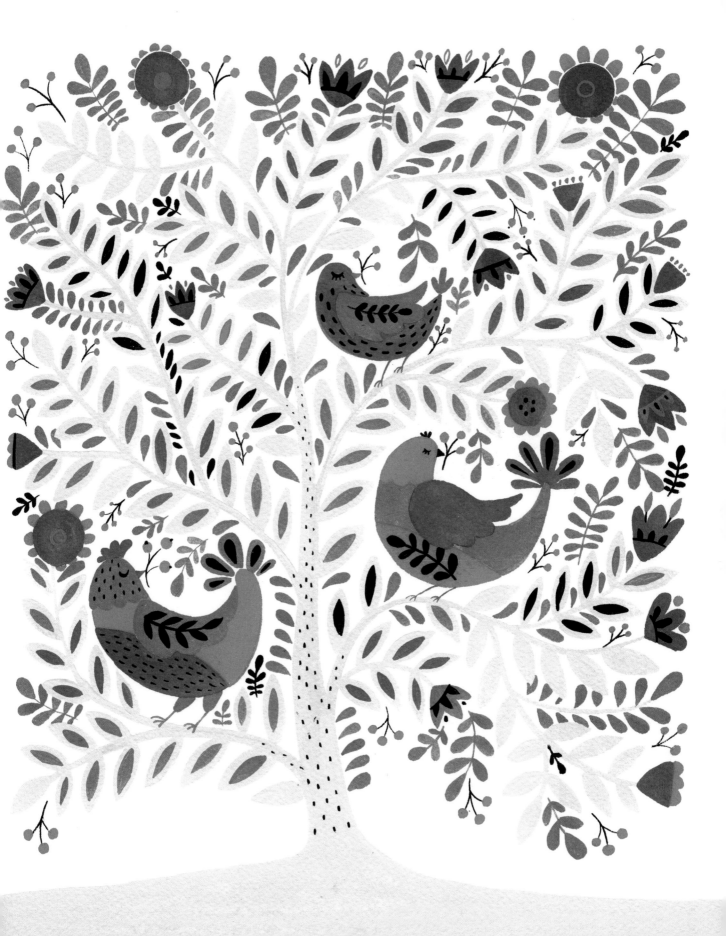

BUTTERFLIES

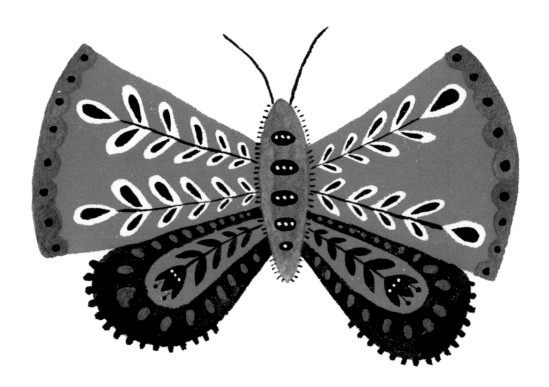

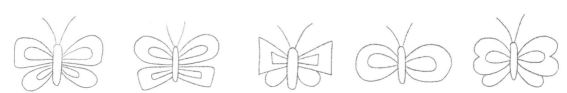

I still remember the day my elementary school art teacher made me redo my butterfly drawing because, in her opinion, "butterflies don't have three wings." It took me years to realize that art is not about accuracy; it is about emotions and how the painting makes you feel. So now, I teach my four-year-old daughter that butterflies can have all kinds of wings, even square ones or an odd number. They don't need to be symmetrical or perfect; what makes them come alive is their lovingly drawn, irregular shape, showing the artist's hand. What makes them sing are the colors you choose and the details you add.

As a symbol of metamorphosis, the butterfly appears in folklore and mythology throughout the world. After all, who can deny the magic in watching an earthbound caterpillar transform into an airborne creature? Open up your sketchbook and draw a dozen different wing shapes before you decide which shape speaks to you. Experiment, be outrageous, surprise yourself! Add some unexpected elements, and play with proportions.

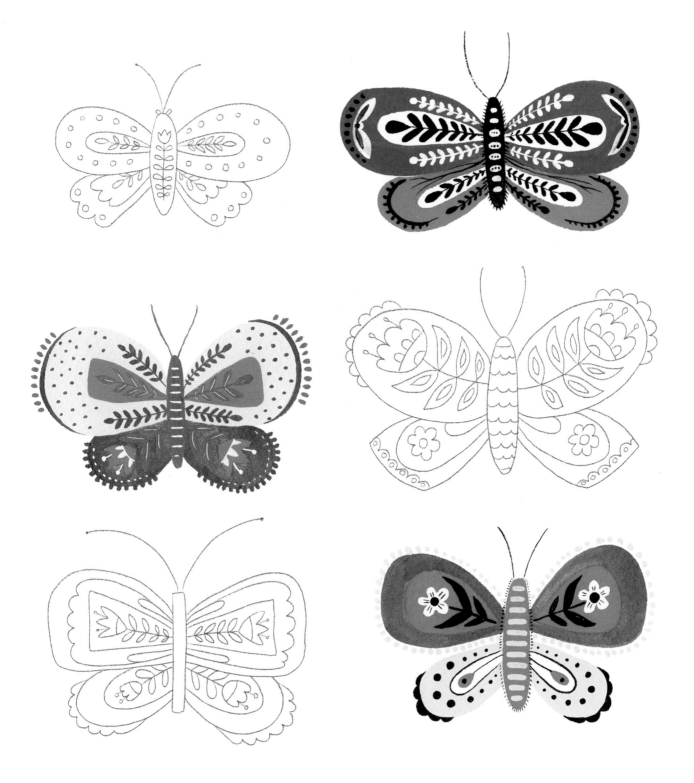

BEETLES

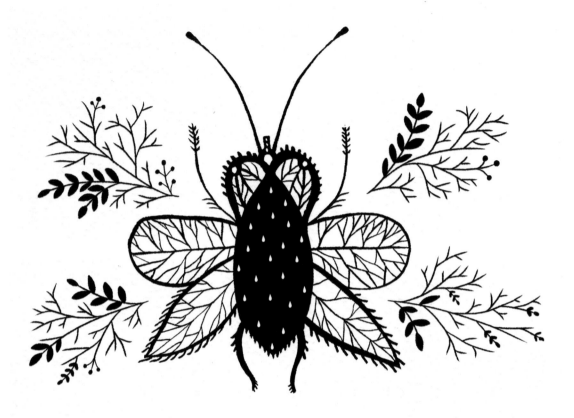

The scarab of ancient Egypt is probably the most well-known beetle in the mythology pantheon. Images of scarabs were carved into stone seals and amulets that were placed over the heart of mummies. Like tiny potters, scarab beetles, also known as dung beetles, roll animal droppings into balls and push them along the ground to their burrows. The ancient Egyptians associated this spectacle with the sun god, Ra, rolling the sun across the sky as it set each night.

There are hundreds of thousands of species of beetles, but just like in the butterfly exercise, they are far more interesting to draw when they come from your imagination. I find their fuzzy legs, chunky bodies, and clumsy bumbling quite charming. These insects come so alive for me that I truly hear them buzzing around me while I'm drawing them.

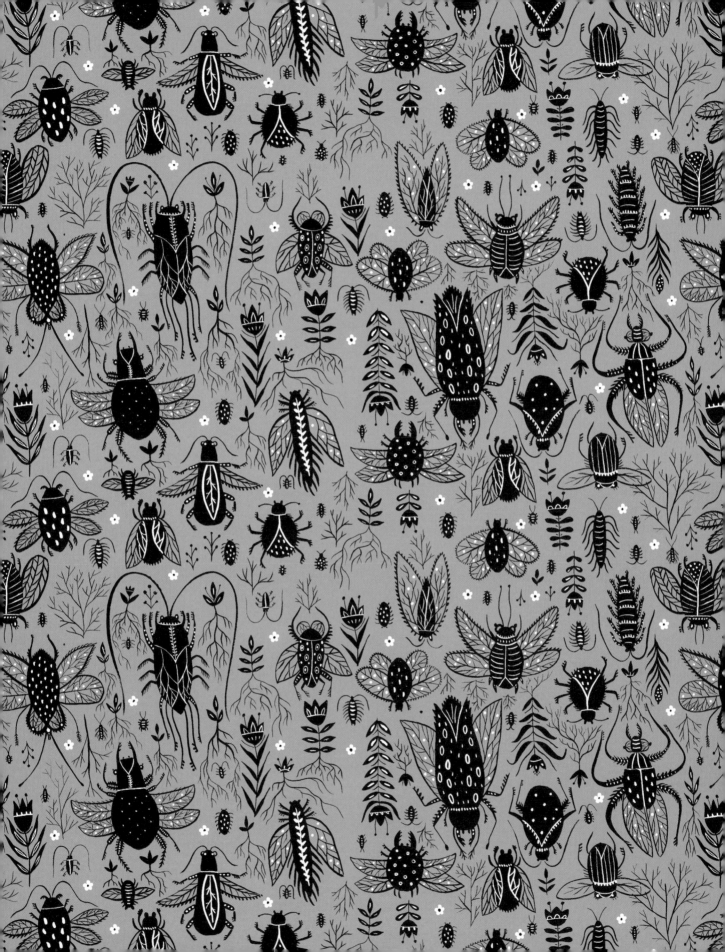

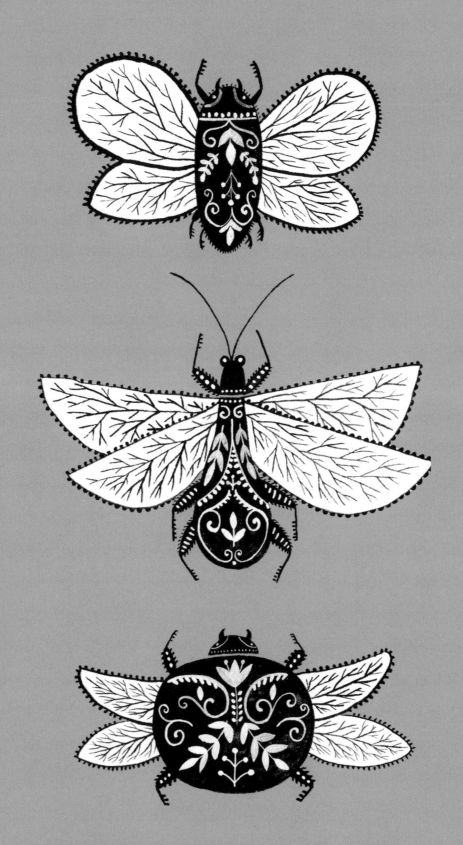

BEETLES

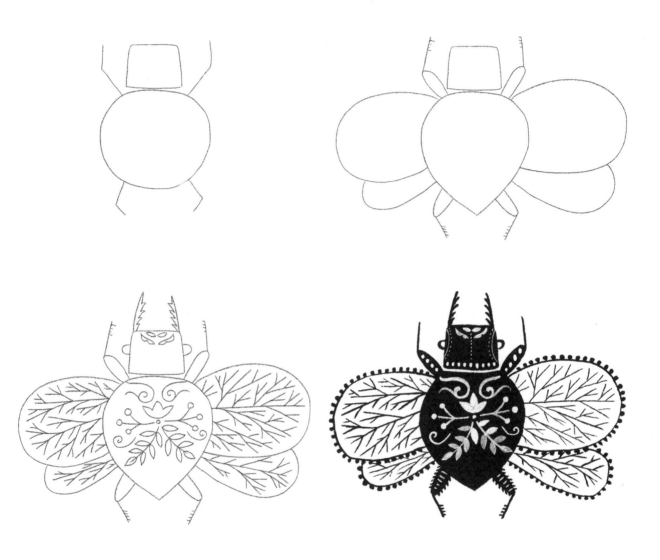

To draw a beetle, start with a simple shape for the head and body. It can be a square or a circle. Decide what kind of wings your beetle will have, and how many legs. Now pencil in your details, including the antennae. Start painting. It's okay if you cover up your pencil sketch with paint. You can always retrace it with a tiny brush. Add decorative elements to the body and the wings. You can fashion your beetle into any size and shape you want.

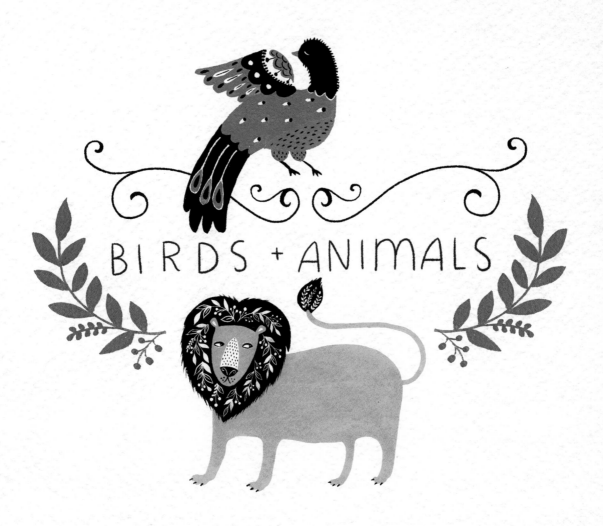

BIRDS + ANIMALS

I FIND THAT IT IS MORE FUN to draw birds and animals that are playful with a lot of personality rather than making them too realistic. I show you how to draw songbirds, doves of peace, and even tropical toucans, as well as hens and rooster, which are traditional folk-art motifs. When drawing the plumage of birds and chickens, especially have fun playing with color palettes and details.

I also show you how to draw a languid, even mysterious cat, specifically my Persian cat, Matilda, but you will be able to draw your own furry friend in no time. And from there, we move on to the regal horse—one of my favorite animals to draw—the melancholy bear and sly fox—both classic characters found in Russian folktales—and the majestic yet kind lion with the most beautiful mane.

BIRDS

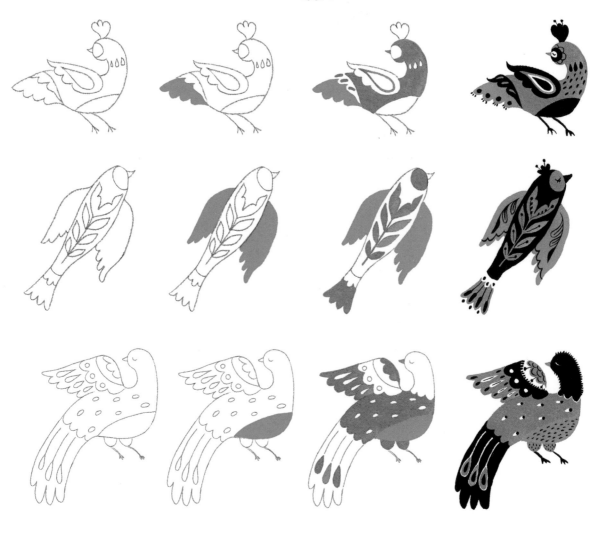

In mythology, the bird is associated with the soul. Because birds can fly, they are thought to be able to traverse worlds and bring back messages from beyond. Some cultures say they are omens of bad luck, but I prefer to think of their messages as sweet and cheerful. I like to think of the dove of peace, the bluebird of happiness, and swans that mate for life.

Start with a basic sketch of a bird's body and decide whether your bird will have a long or short tail, open or closed wings, be in motion or sitting on a tree branch. When it comes to

painting, I prefer a limited color palette of no more than three colors. There's no rule on whether you should start painting the body first or the details. You will know as you start. The only thing I try to decide right away is which areas I'd like to leave blank. I simply don't paint over those areas and paint around them. You can use white paint if you want, but it is not going to be true white (which is perfectly fine sometimes!). Simply let your own artistic imagination take flight.

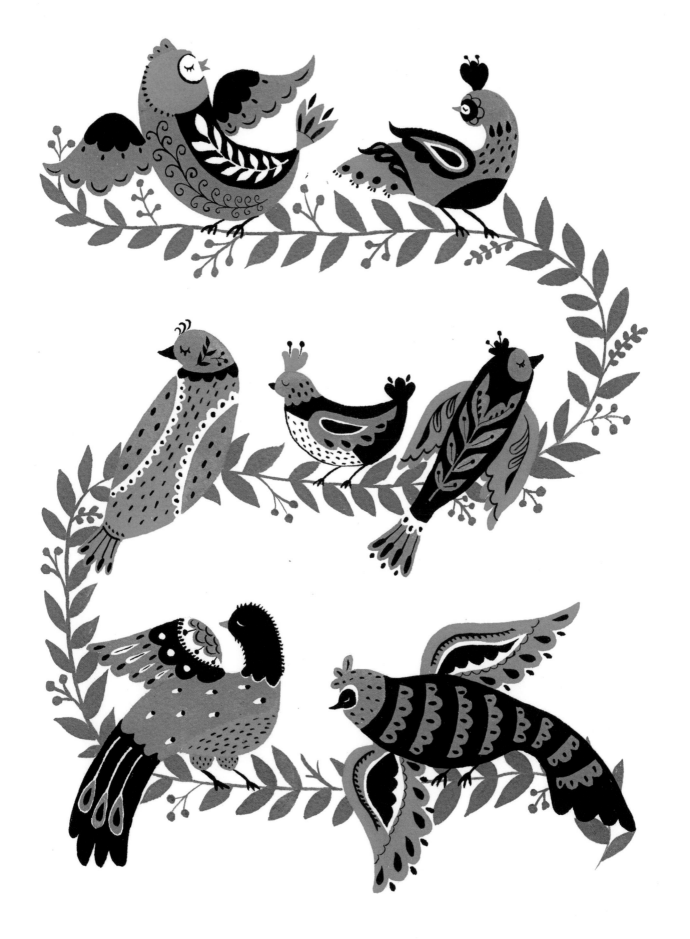

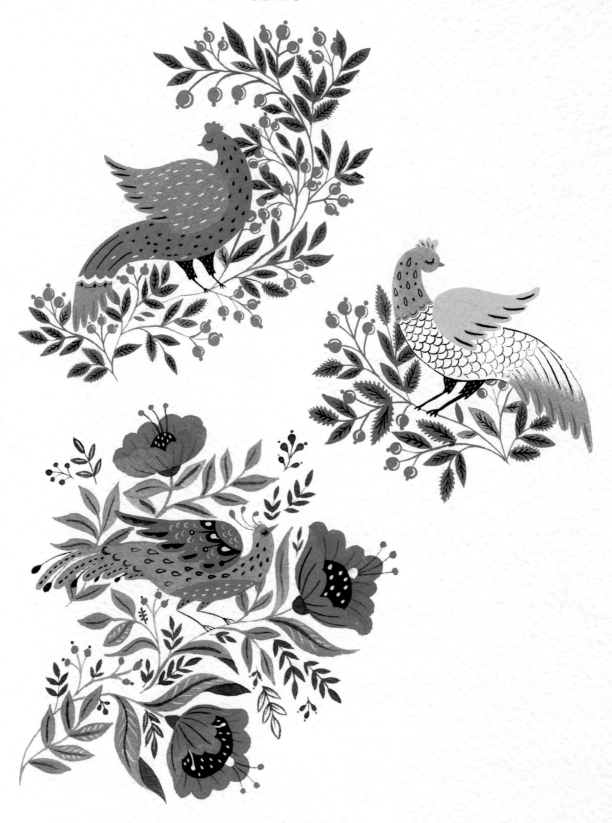

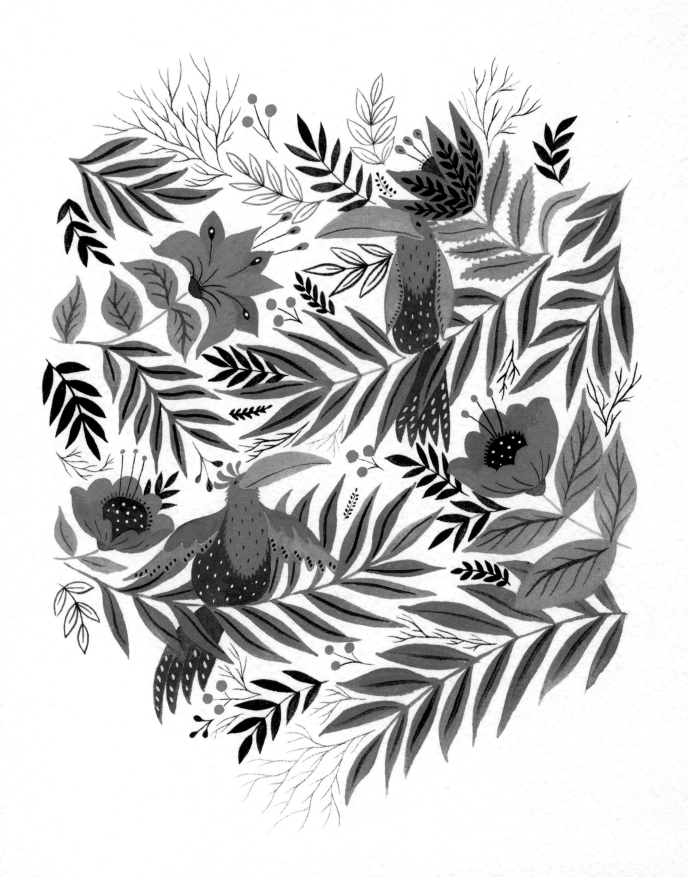

BIRD IN THE FOREST

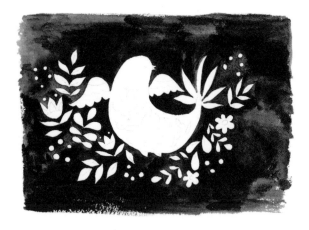

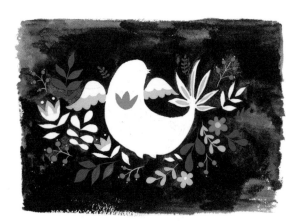

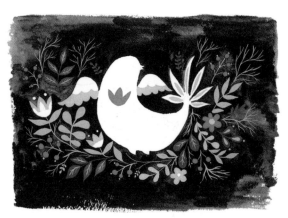

I start with painting the background. I like texture, so I purposefully leave the gray washout areas because I find them interesting. Then, I add brighter colors, such as red and orange, followed by tonal shades of green. And I finish by sprinkling delicate details throughout the painting, and then adding a few black elements.

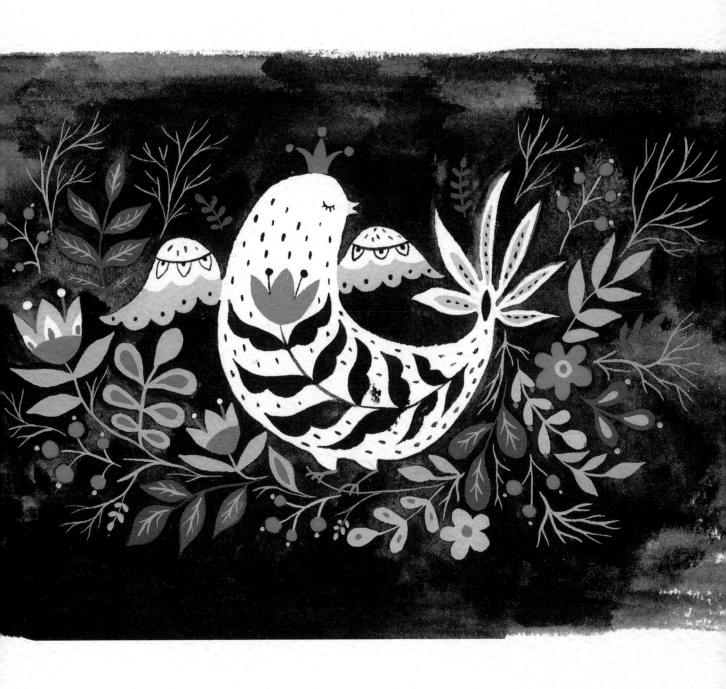

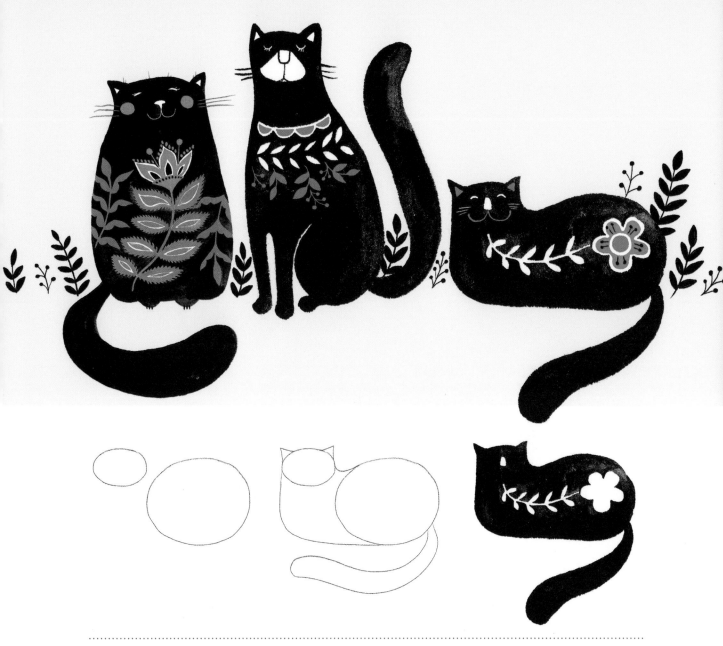

My furry Persian friend Matilda is my great inspiration for drawing cats. She accompanies me at night when I'm sitting and painting. She's there to watch my every stroke, and she stoically poses for my Instagram pictures. Very graceful with the air of royalty, Matilda first made her appearance on my greeting cards, and she has greatly influenced many of my animal art motifs.

Cats have a mellow, languid aura, so I tend to draw their body shapes with very simple lines, often as a one long sack with little paws and pointy ears. The tail is an important part of a cat's expression, whether it is softly curved in front or poised at attention to the side. I like to add folkloric decorations that provide a sense of movement to an otherwise regal pose.

Sleepy cats remind me of a shoe box. They hide their paws and tuck them under themselves, creating a rectangular shape. To draw a snoozing cat, sketch your head and body circles nearly side by side.

CATS

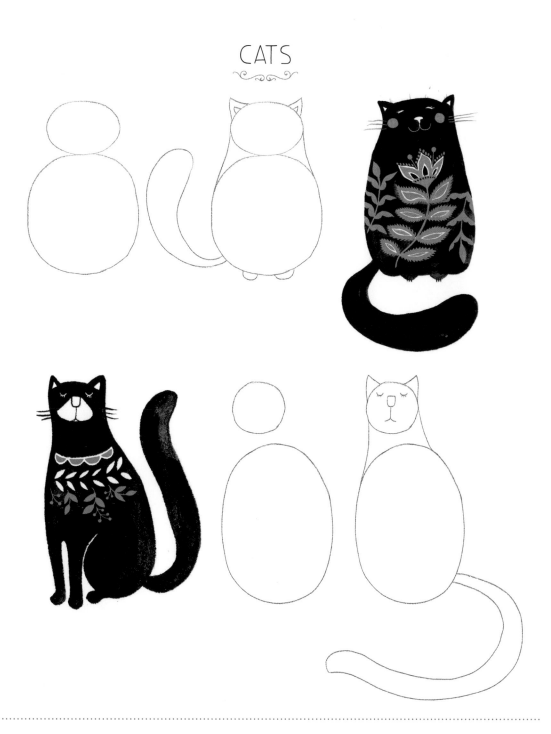

To draw a rounded cat, sketch two circles for the head and the body, making the upper circle a bit smaller. To make the cat appear rather plump, draw your circles with a bit of an overlap. Then, outline the body, adding pointy ears and a tail.

To make a slimmer cat, draw the circles in a more oval shape and farther apart from each other, which will allow for a longer neck. Outline your ovals and add pointy ears and a long tail. You may also add paws, as lean cats are more graceful looking.

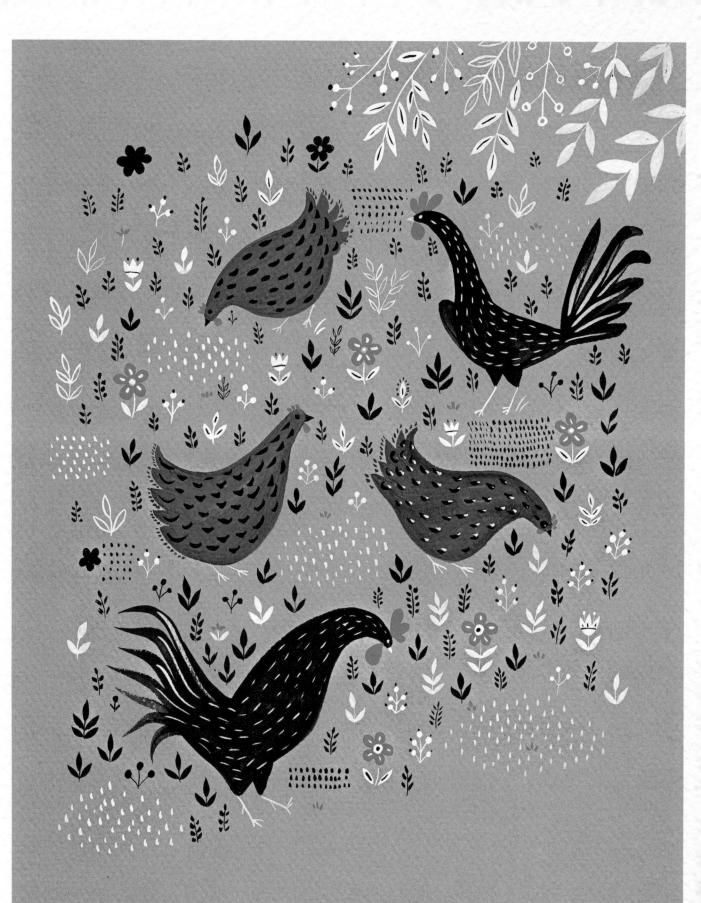

CHICKENS

Hens and roosters are common folk-art motifs, perhaps because they convey a simple country life of barnyards and fresh eggs. With so many different varieties of chickens, you could spend from sunup to sundown exploring their many colors, shapes, and plumage. Two typical postures are a chicken pecking at the ground for worms and a hen sitting on her nest, warming her eggs before they are snatched by the farmer's wife for breakfast. Roosters, known for crowing at dawn and waking up an entire village, herald a new day. They strut around the barnyard, protecting the hens and warning of intruders. As a symbol of bravery, roosters have decorated the flags of various nations for centuries.

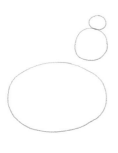
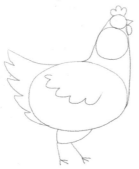
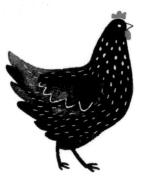

To draw a chicken, start with a small circle for the head, followed by a larger circle for the neck, and finish with the largest circle for the midsection. Connect the circles to make an ample breast, and then add the tail feathers, wings, a beak and wattles, and a modest comb on top of the head. Finally, balance the chicken on top of its spindly legs, which look as if they couldn't possibly hold up the chicken's plump body.

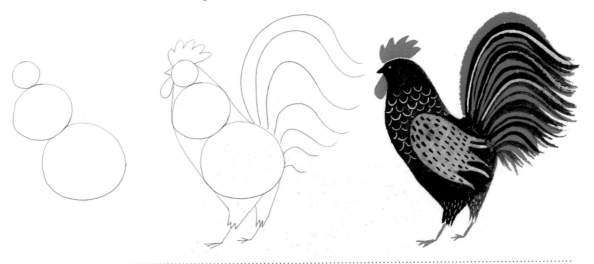

Roosters are taller and leaner, with a circle for the neck that is almost the same size as the circle for the midsection. Their larger combs and wattles, and their gorgeous tails and colorful feathers, provide opportunities for lively expression. Just don't let him wake the neighborhood.

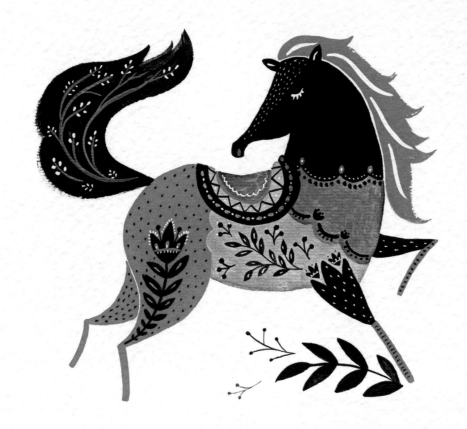

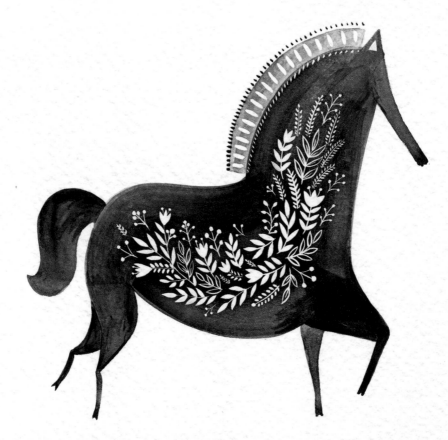

HORSES

Horses have been my favorite animal to draw ever since I was a young girl. My way of drawing horses includes a skinnier face, pointier nostrils, a chunkier body, and abnormally slender legs that in real life would never support a horse's body.

The horse's mane and tail add a great deal of character and drama. Sometimes I draw the mane long and flowing and sometimes I prefer it more masculine and short.

I also love looking at historical art references to see how Arabs, Indians, and Vikings decorated their horses with astonishing armor and finely tooled saddles. The amount of delicate embroidery, decorative metalwork, colorful beads, and precious stones made these animals truly works of art.

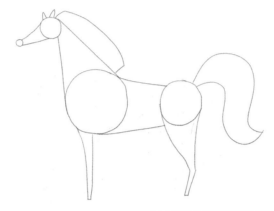

The simplified anatomy of a horse consists of three parts: the head, which I draw pretty small compared to the body; the chest, which is the largest circle in my sketches; and the buttocks, which is a smaller circle than the chest but larger than the head. Connect the circles as shown in the example, and then add the muzzle, legs, mane, and tail.

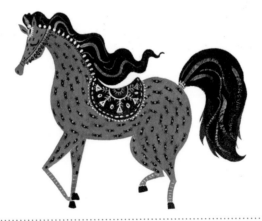

In this example I have painted a horse in color blocks, where the head, body, and buttocks are all separate shades. This is a great exercise to help you think about your drawings in a more abstract way. This horse has a short, masculine mane; however, I still like to combine the stereotypes of masculine and feminine and decorate the body with folkloric flowers and an ornate saddle. A few lines of dots add dimension to the face.

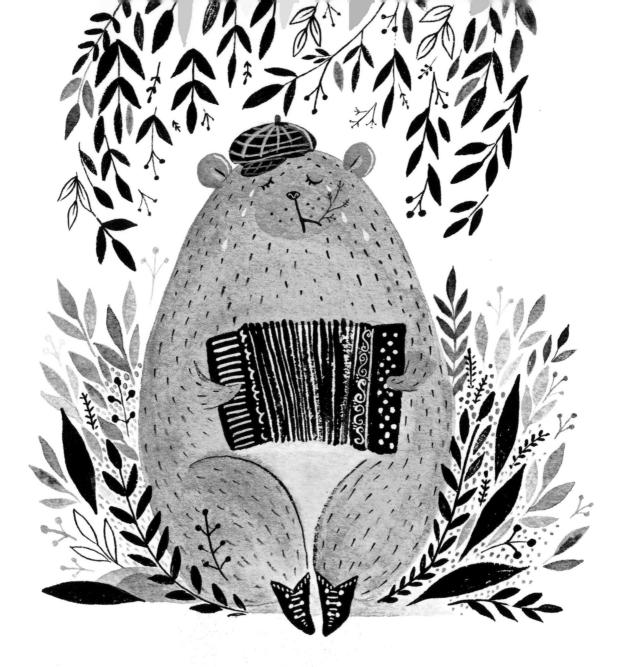

I grew up hearing Russian folktales from my grandmother, who came to Uzbekistan from Russia as a girl during World War II. She fell in love with my grandfather and made Uzbekistan her home. Sitting in her lap, I was enchanted by her stories of a Russian bear who was big and clumsy, but kind and charming, too. He always sounded a little wistful, like he was in need of love and companionship from a young child or a small, vulnerable animal who was not afraid of his large size and shaggy fur.

Combining a huge animal, such as an elephant or a bear, with a tiny but intelligent creature, such as a mouse or a bird, is a favorite technique of children's book illustrators. The child sees herself in the small, defenseless companion and tames her fears by becoming friends with an enormous bear.

In my artwork, I also love playing with such opposites: large and small, strong and tender. In this example, I reveal the sensitive side of a huge grizzly, who is playing a sad song on his accordion and yearning for his true love.

BEARS

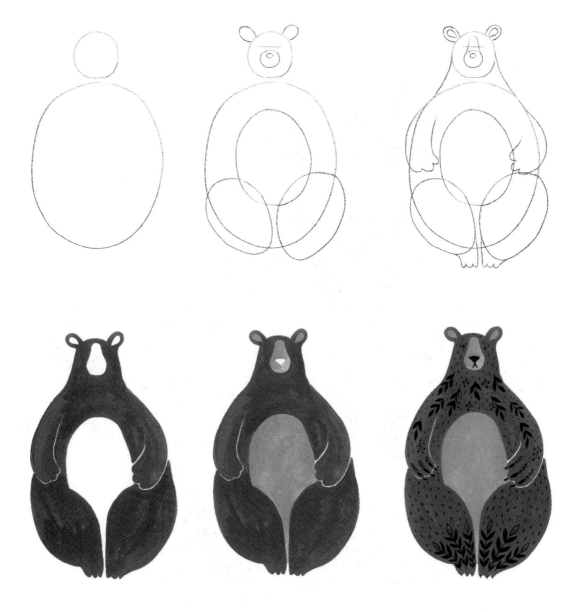

It's fairly easy to draw the shape of a bear, which has a very rounded form with attentive little ears and plump mitten paws. My rough drawing shows how you can sketch out the body without getting too carried away with anatomy and proportion. Start with a small circle for the bear's head and add a fairly large circle for the bear's body. Connect the circles with a thick neck and add details such as ears, paws, a nose, and eyes. Paint in some nature-inspired, folk-style motifs to cheer up your melancholy bear.

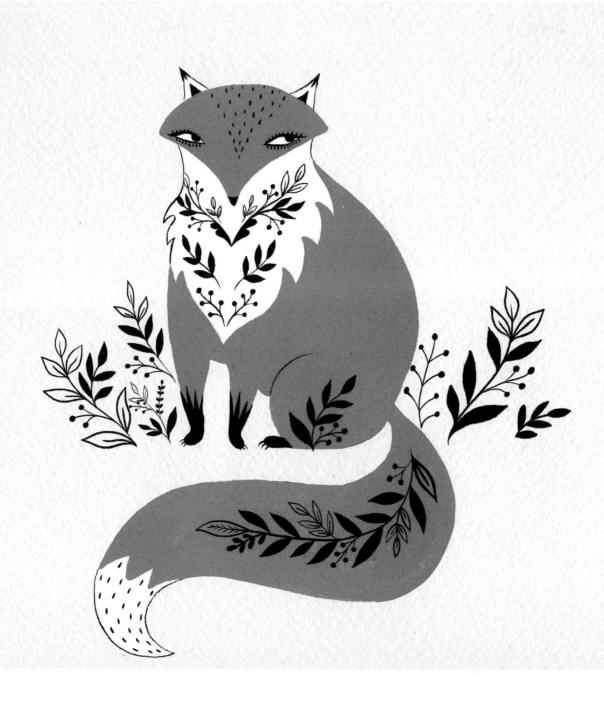

FOXES

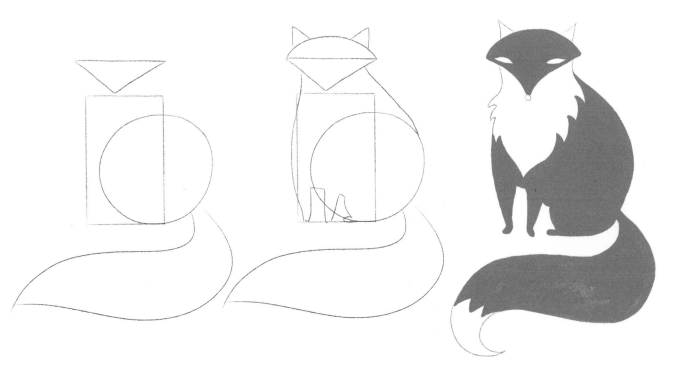

The fox is another prominent character in Russian fairy tales. She is usually known for being slyly smart to achieve her selfish aims. She's the one who speaks softly and sweetly, and then steals the chicken and gets the wolf in trouble. To me, a fox is such a mysterious character, perhaps because her eyes are so cunning and alert. She is watchful, patiently waiting for her plan to unfold.

Foxes have a triangular facial structure, a chunky body, and a long, furry tail. Take a look at my quick sketch to see how I draw a fox in a sitting position. I find sketching a fox is very similar to sketching a cat; however, the fox's unique facial features, such as a pointy snout and spiky ears, set it apart. My fox has a delicate nose and big, wide eyes. I also like emphasizing her white fluffy collar, floaty tail, and dipped-in-ink black socks. Folkloric motifs emphasize her white chest and looping tail, and her sidelong gaze suggests powers of observation honed by ages of mythological trickery.

LIONS

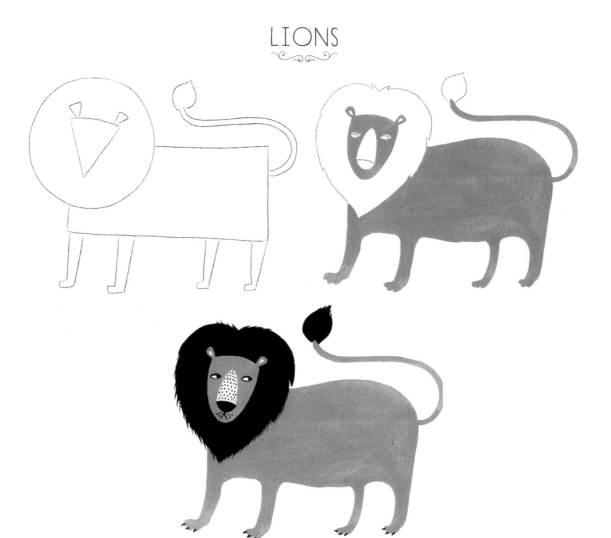

Lions, as kings of the forest, are known for being rulers in many children's stories, so when drawing a lion you can make him either powerful and vicious, or sweet and friendly—that's a personal choice. My lions vary from drawing to drawing. I love reading about medieval flags where lions were often used as a symbol of power. Those lions are typically shown with sharp teeth and claws in a pose that clearly sends a message that they are ready to attack if necessary. Because of its regal bearing, the lion is also a common symbol on many coats of arms for royal families. Tthe other type of lion that I use in my illustrations is as a very sweet animal.

Lions are wise and knowledgeable, and they have kind eyes and a beautiful mane that is a joy to decorate. The furry tip of the tail is another charming place to add embellishment. To sketch this lovable type of lion, start with a big circle for the mane, and then add a boxy or rectangular body and a triangular face. Lions also have huge noses that take up almost half of the face. The eyes are important for conveying your lion's mood, and in this example, my lion is dreamy and calm—I drew his eyes looking sideways, rather than straight ahead in a challenging stare. I encourage you to experiment with different facial expressions to convey just the right temperament for your lion.

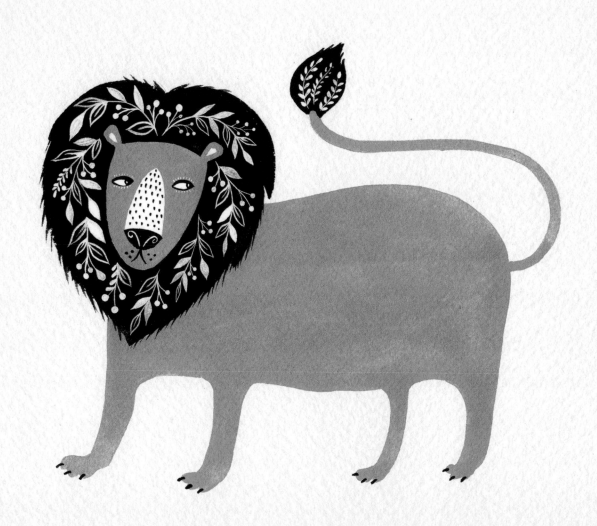

FAIRY TALES + MYTHICAL CREATURES

YOU CAN REALLY ALLOW your imagination run with wild abandon in this chapter! Have fun with the beautiful, ornate costumes of kings, queens, princesses, princes, and knights. Draw towering the castle of your dreams. Perhaps there's a moat? Transport yourself to the Middle East—think the thrilling Arabian Nights and colorful Persian miniature paintings dating back to the thirteenth century.

Moving on to mythical creatures, the Russian firebird, the birdlike Sirin, the enchanting mermaid, the fire-breathing dragon, and the beastly griffin are included for your drawing pleasure.

Finally, there's nothing more representational of folk art than the Russian matryoshkas, traditional wooden nesting dolls. Here, I'll guide you to paint your own versions, even on wood!

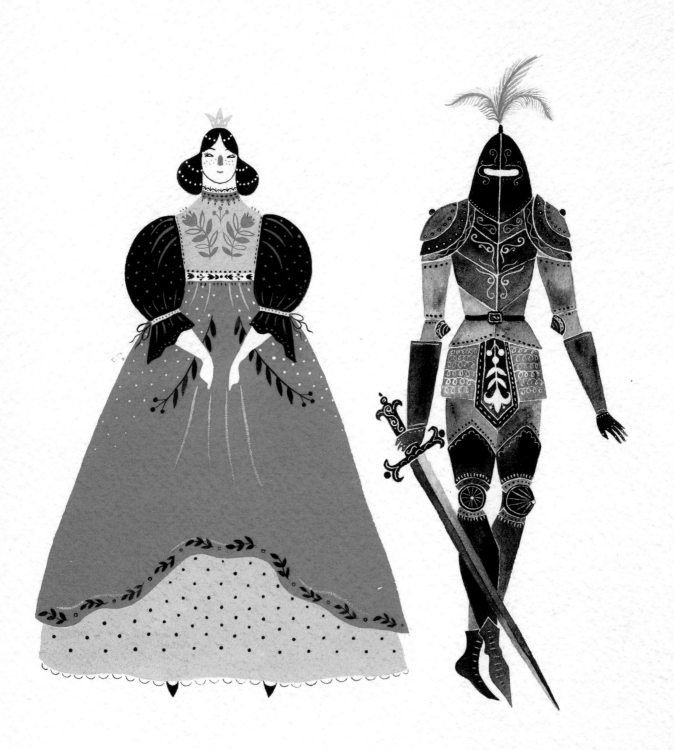

ROYALTY AND KNIGHTS

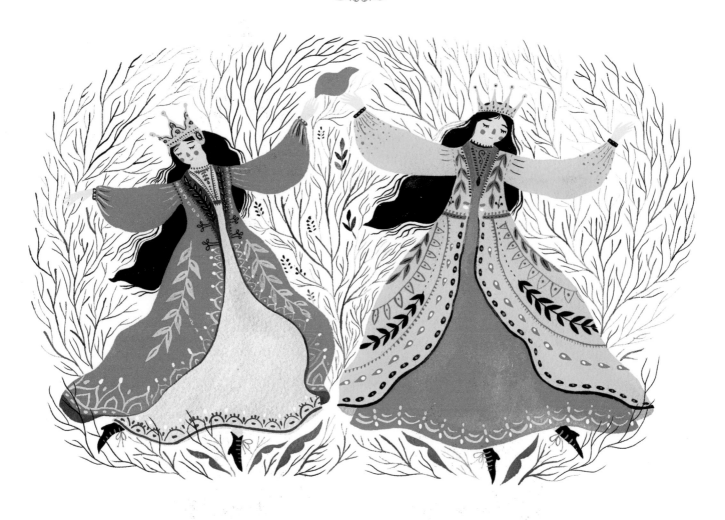

How I love to draw princes and princesses! As a child I was fascinated by their long gowns and glittering crowns, and I had a drawing album filled with their different hairstyles and dress designs. As a grown-up, I still enjoy watching medieval movies, reading about kingdoms, and admiring Renaissance art at museums.

Now, as a mom to a little girl who is also passionate about princesses, I find it joyful to draw them over and over again. I admire how people used to dress in that era; the level of embroidery is true craftsmanship beyond anything we see today. I'm a hopeless romantic who wishes women still wore ball gowns to stroll in their formal English gardens, but alas, in my ordinary life, I get to enjoy it only on paper. When I draw a princess, she must wear an exquisitely detailed gown with frills of ribbons and glittering jewels.

My knights are also quite detailed, with their intricate suits of armor and finely wrought swords. My kings tend to be very small and have soft, rounded forms, while their queens are spoiled, gritty old ladies who like wearing makeup and a small fortune in jewelry.

CASTLES

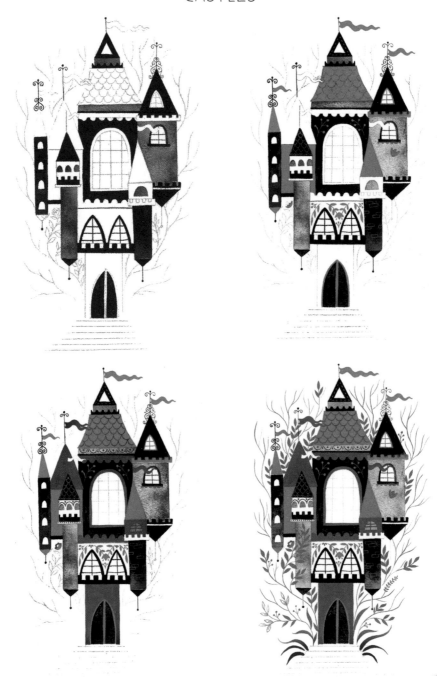

To draw a castle you need to have a tall sheet of paper, as castles tend to be towering structures. Medieval castles were impressively decorated. I like the huge windows, ornamental balustrades, and heavy iron doors. I also prefer to use a limited palette of colors for my castles. Here, I use regal shades of red and gray with accents of gold and some black for contrast.

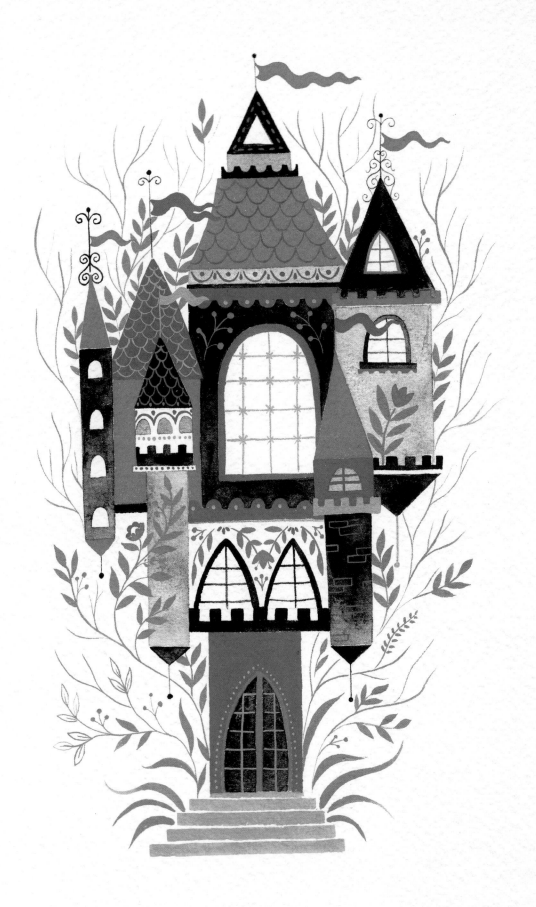

MEDIEVAL SCENES

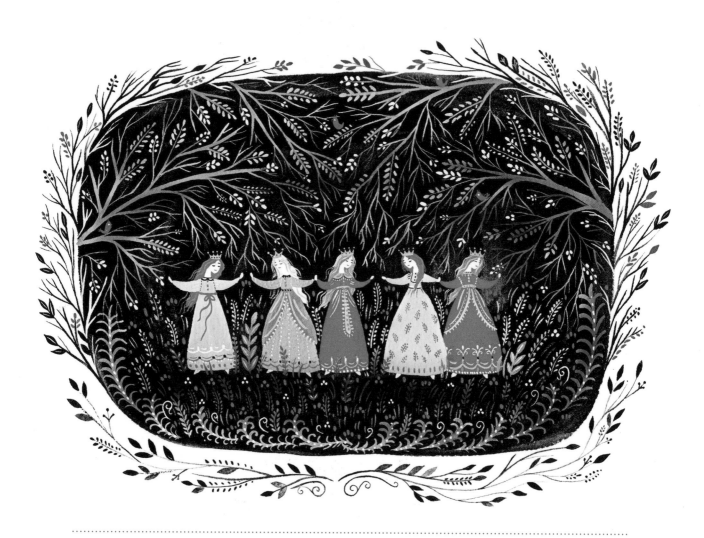

When drawing medieval princesses, I like to emphasize their magical, mysterious surroundings, whether it's a dark enchanted forest or a turreted castle on a towering hill.

I love to decorate my illustrations with fluttering flags and floral motifs, which I find add drama to a feudal landscape.

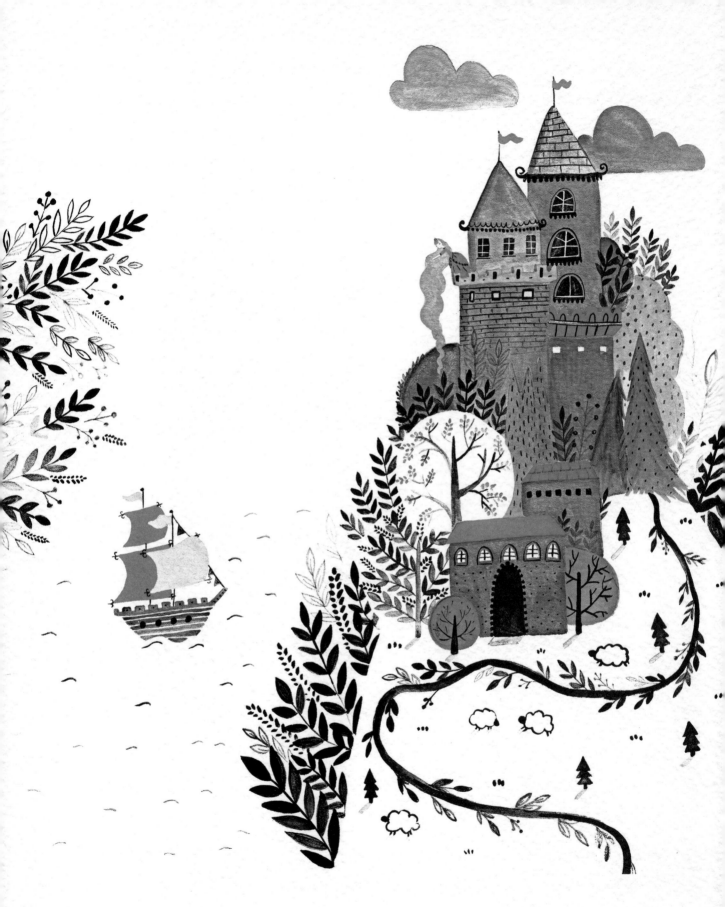

MIDDLE EASTERN AND ASIAN TALES

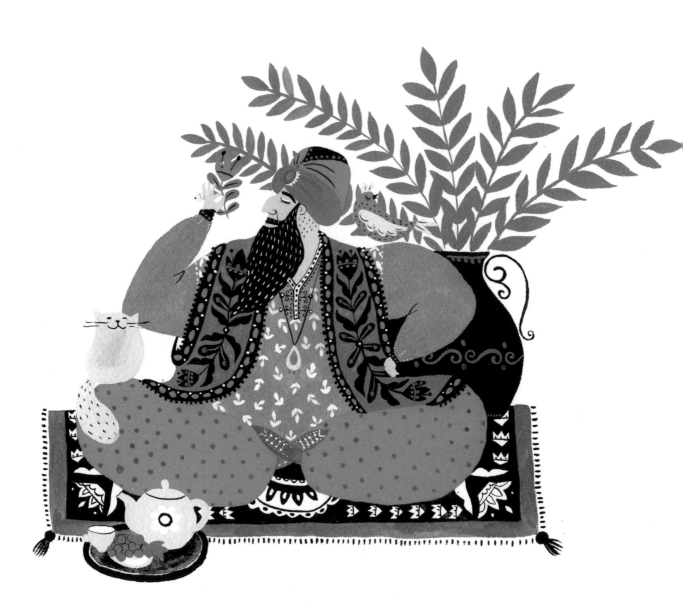

The traditional dress of people from the Middle East and Asia differ from region to region, and I'm far from an expert on this subject. But often, women covered their heads with organza scarves and men sported turbans and long beards. Gold and jewelry were a sign of wealth, and people of these nations liked to generously decorate their garments, as well as their horses, with precious stones and ornaments fashioned from gold.

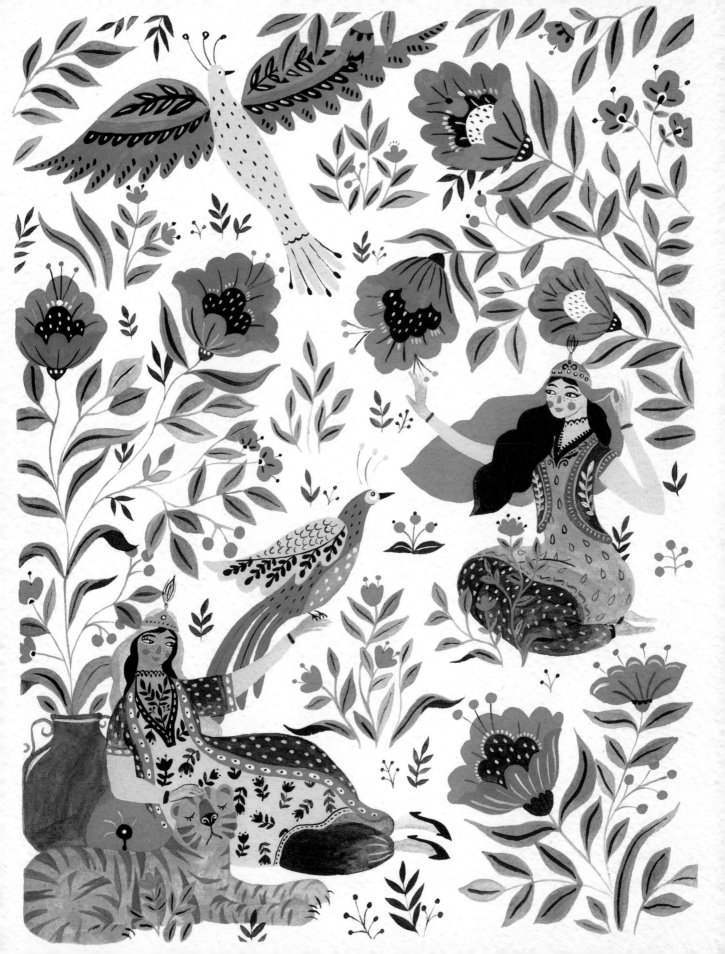

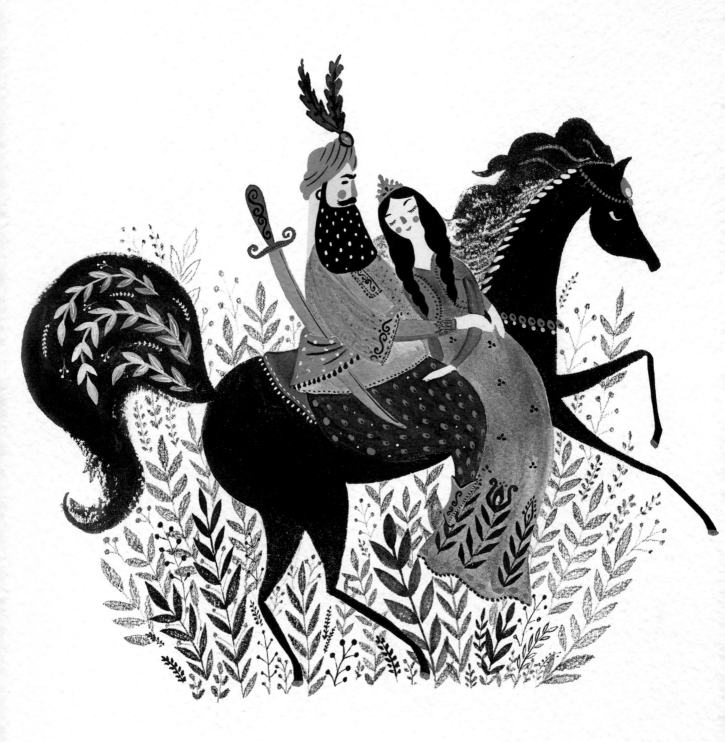

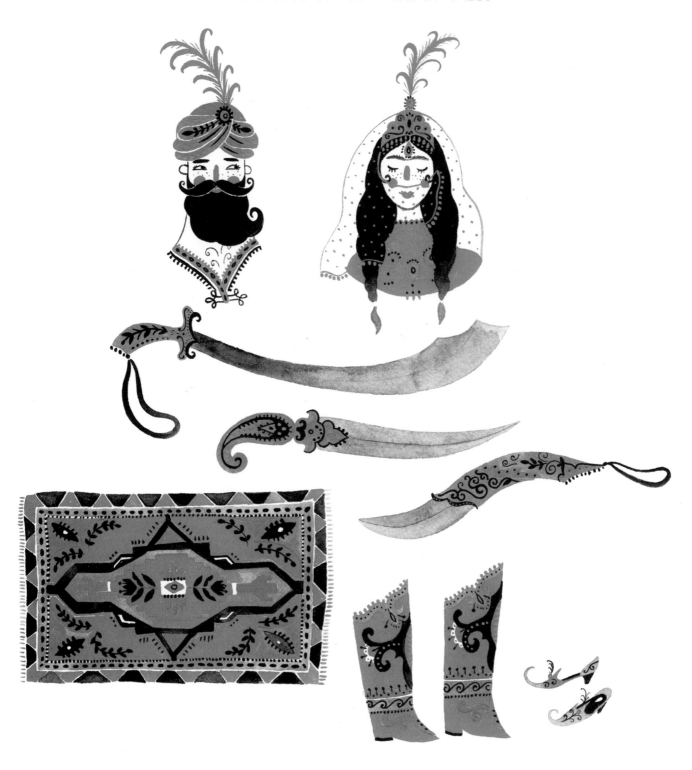

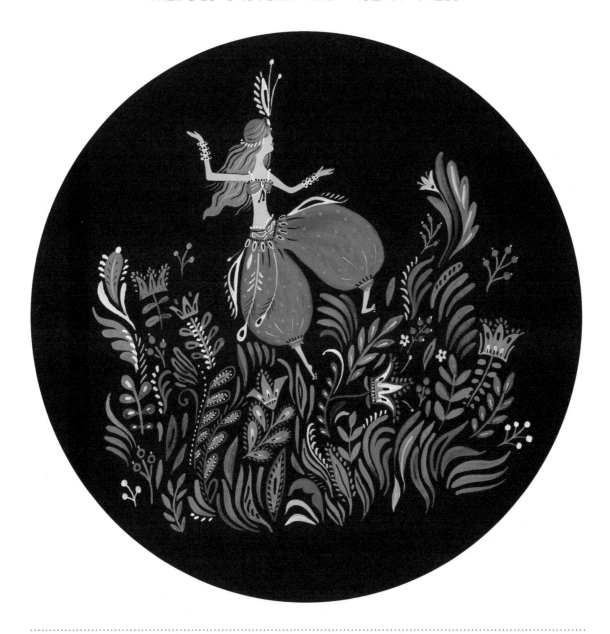

In my illustrations, sinuous belly dancers from Middle Eastern and Asian fairy tales wear puffy chiffon pants and cropped bustiers that bare their midsection. They also wear coin belts on their hips that jingle when they dance. When I draw belly dancers, I also like adding feathers to their headpieces and an armload of bracelets. Listening to beautiful mandolin music while I paint helps me get into the mood of the piece and feel the character I'm drawing.

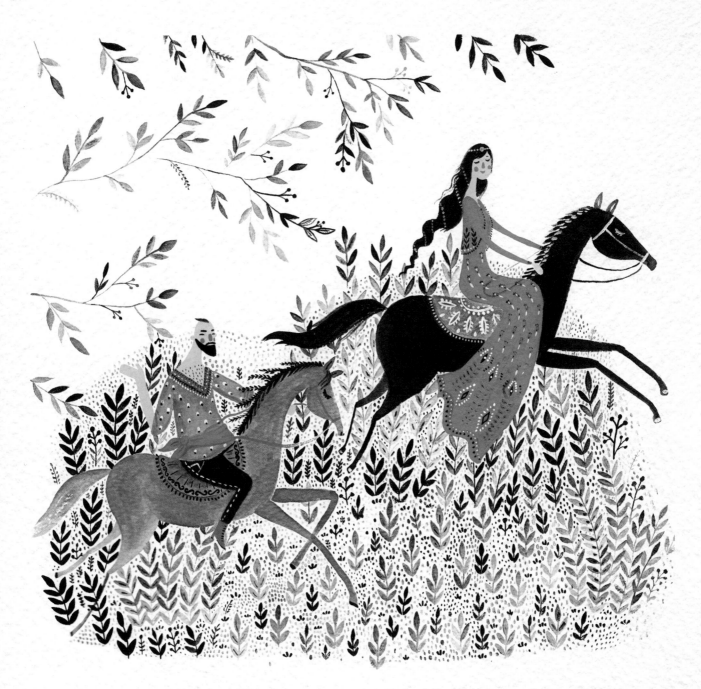

Just like always, young people fall in love, and in fairy tales, a sequestered princess just might fall in love with a poor but handsome villager. In your illustrations, you can show this attractive young man as humble but kind by making him slender and unadorned. A princess would wear a splendid, richly decorated gown. In this illustration, my princess is running away with her true love. She doesn't care for palaces and gold, just the happiness that awaits with the man who has captured her heart.

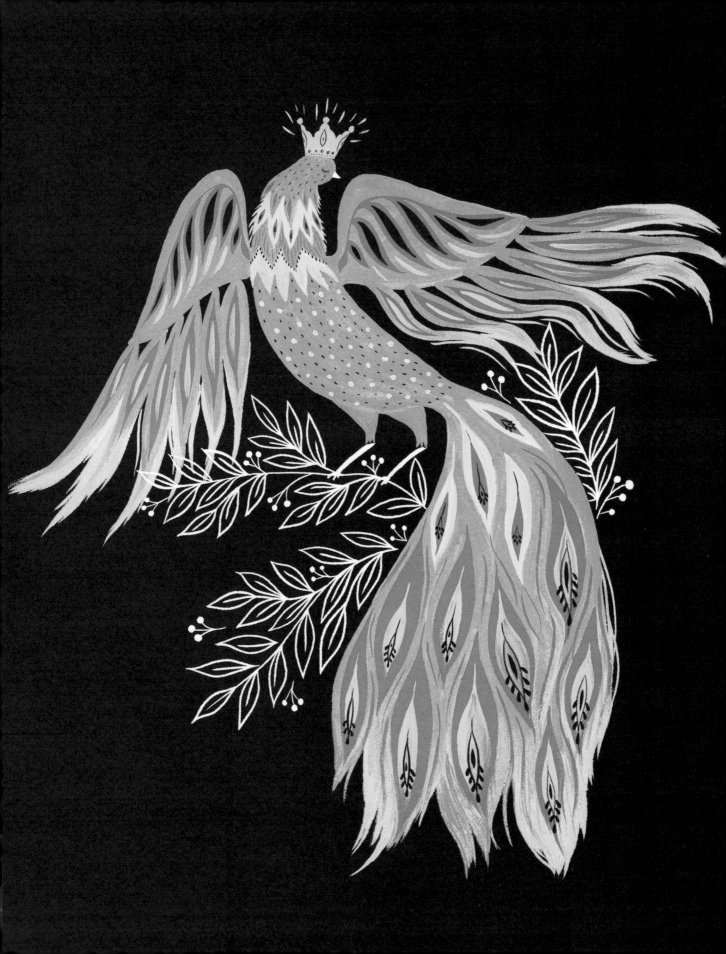

FIREBIRDS

Firebirds are mythical creatures of Slavic folklore that are often described as majestic birds whose feathers are aglow in red, yellow, and orange flames. According to legend, these magical birds hail from a faraway land and bring both a blessing and a curse to those who find or hunt for the firebird's feathers.

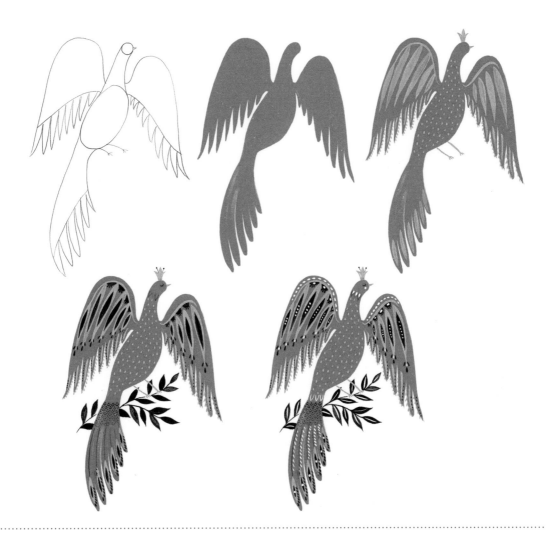

I draw a firebird just like any other bird, except I like to add longer feathers to the wings and tail, sometimes in the form of flames, and a thinner and longer neck. Start your sketch by drawing a small circle for the head and add a much larger oval for the bird's body. Connect them with a wide, curving neck. You have the freedom to draw the wings as wide as you prefer and the tail as long as you wish. Remember, it's a mythical creature and you get to decide what it actually looks like. Paint the entire body in brilliant red and add yellow feathers to the wings and tail. Include details in black and white for contrast, and perch your firebird on a small branch so he can rest after the long flight from his distant land.

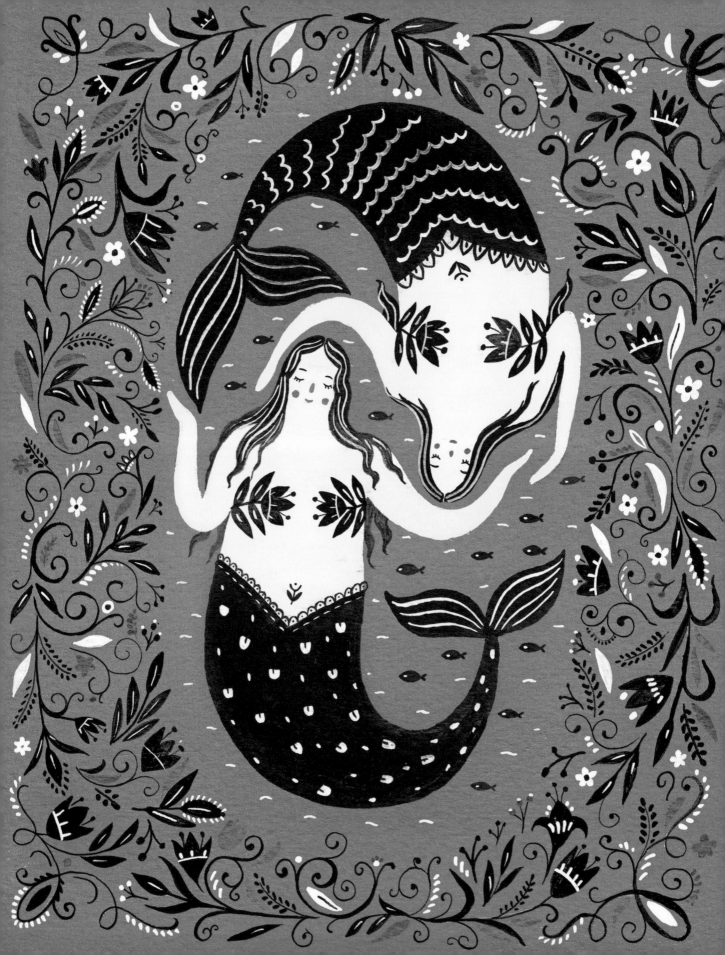

SIRINS AND MERMAIDS

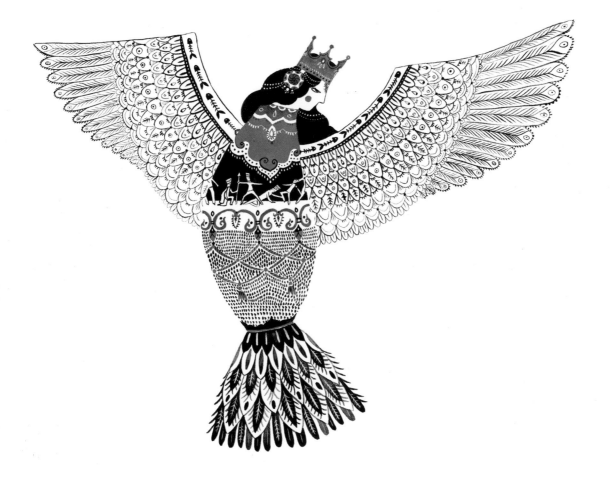

Another mythical creature that I love to draw is a Sirin, which has the body and wings of a bird and the head and chest of a beautiful woman. She is often depicted wearing a crown. In Russian mythology, Sirins, like the Sirens of Greek mythology on which they are based, have the ability to mesmerize human beings with their enchanting voices, leading them into danger from which they will never return. Thus, any mortal who hears the Sirin sing is inevitably destined to die.

Drawing a Sirin is just like drawing a bird, except you draw the face of a beautiful woman where the bird's head would be. I like my Sirins to have long hair and I also give them the traditional crown. I often spend many hours working on the details of the feathers, chest, and tail because I like my Sirins to be highly ornate. You can also give her a branch to perch on as she serenades any unsuspecting souls below.

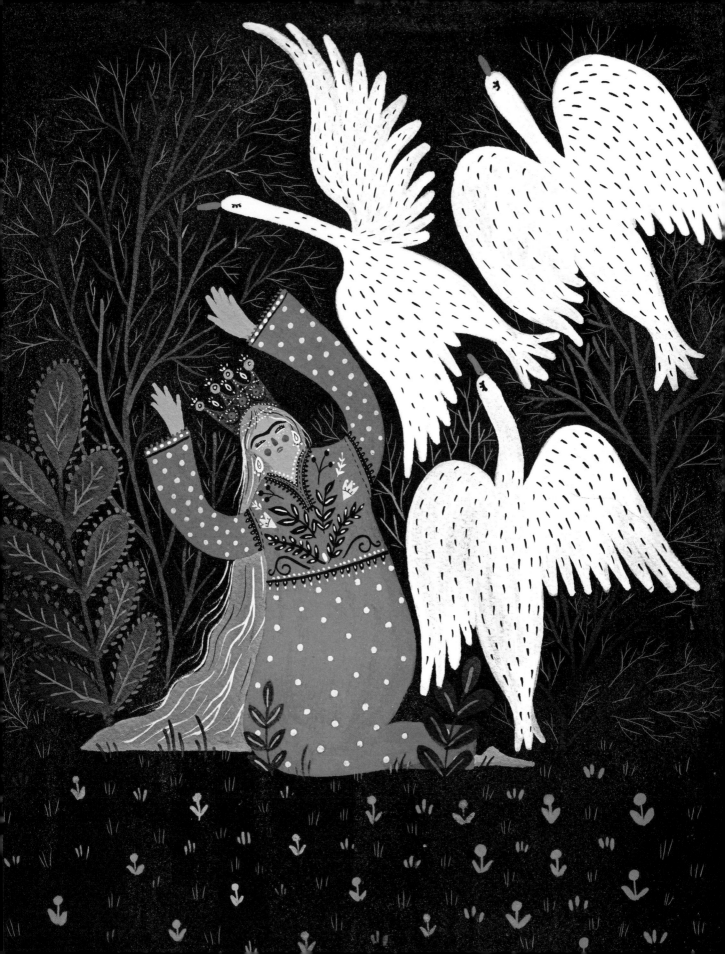

SIRINS AND MERMAIDS

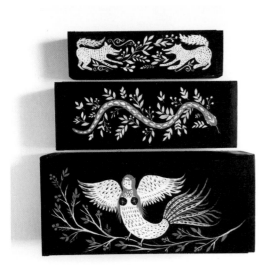

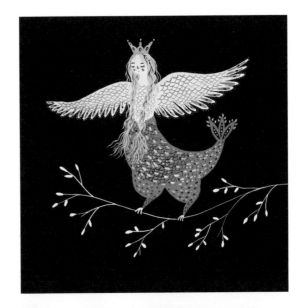

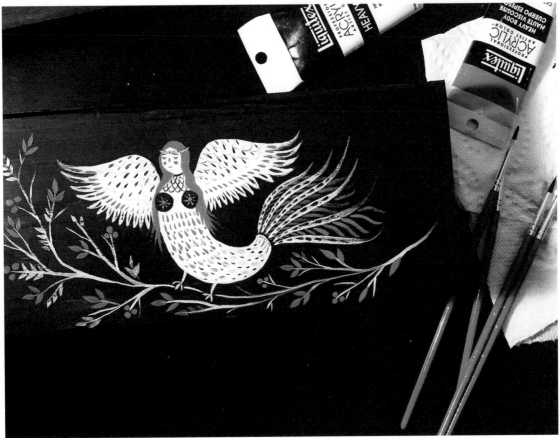

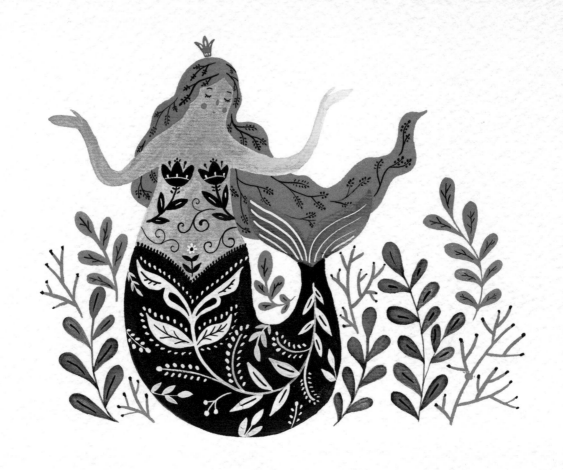

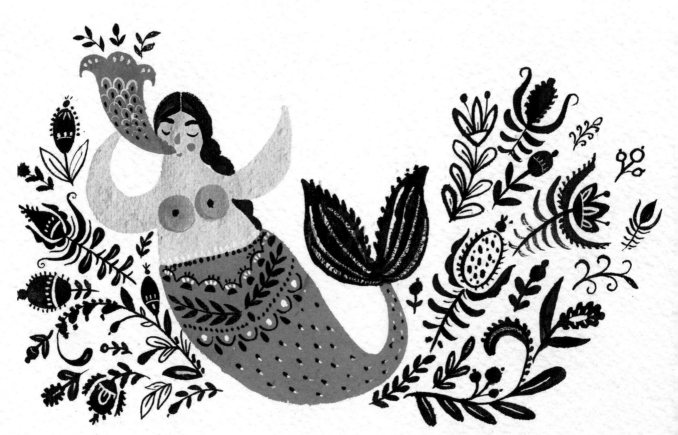

SIRINS AND MERMAIDS

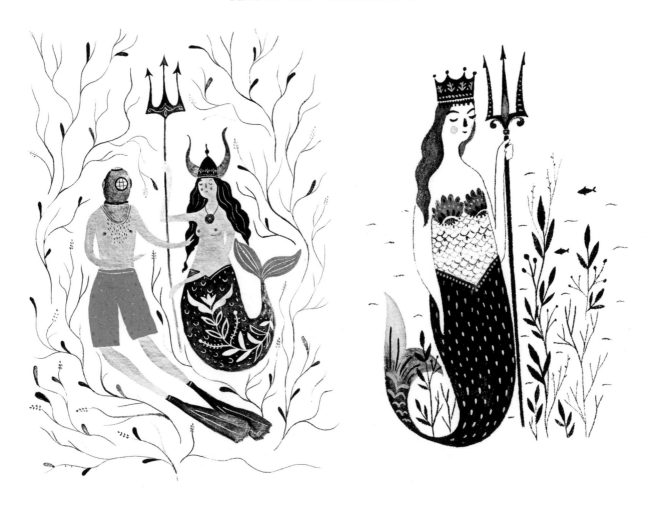

Mermaids hold a popular mythological place in the human imagination. These underwater creatures with the upper body of a woman and the tail of a fish first appeared in Assyrian legends from the ancient Near East. In Greek mythology, mermaids are associated with Sirens, beautiful yet dangerous creatures who lure sailors with their enchanting music to shipwreck their boats against rocky shores. In more recent popular culture, the mermaid is a wistful creature who longs for a human soul.

I rediscovered the appeal of mermaids when my daughter became smitten with them and asked me to draw them for her. I loved the challenge of drawing different kinds of mermaids. My mermaids tend to be very curvy and rounded because I feel that's a great body image.

To draw a mermaid, start your sketch like you would normally draw a woman, but instead of two legs, just draw a curvy tail. You can draw your mermaid with bare breasts or cover them with shells, vines, or flowers. My mermaids have long hair that is sometimes depicted as seaweed. I like decorating the tail so much that I treat it almost as if it's a dress. Sea vines and coral place the mermaid in her underwater home.

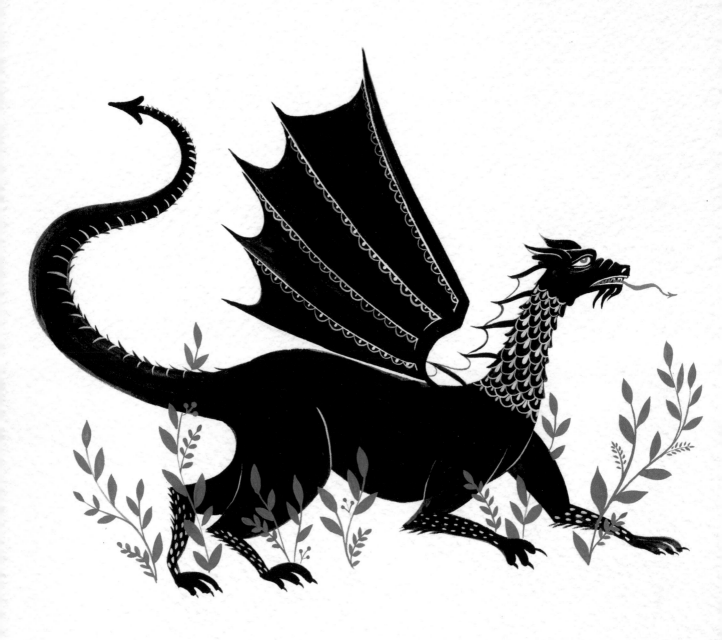

Dragons are large, reptilian creatures that appear in the mythology of many cultures. They typically have the body of a giant lizard and huge bat-like wings. Other features may include scaly skin, horns, a powerful prehensile tail that acts as another limb, a dinosaur-like crested back, razor-sharp claws, and, occasionally, more than one head. Dragons are notorious for breathing fire from their mouths. In folklore, the dragon often guards a treasure, and slaying the dragon is a dangerous and heroic act.

DRAGONS

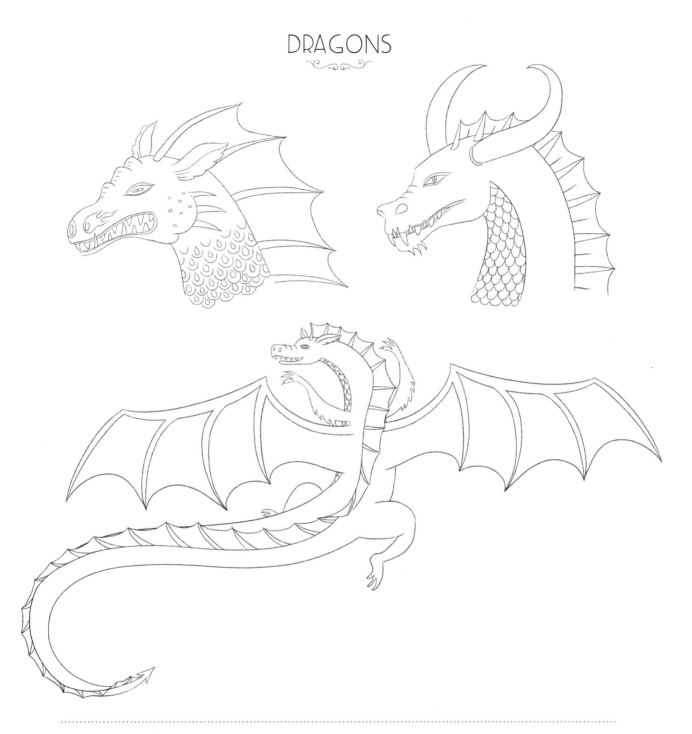

When I draw dragons I love emphasizing the scaly, snakelike skin, the spikes on its back, and the majestically huge wings. I also like giving my dragons clawlike paws and strong, furry legs. Since nobody has really ever seen a dragon, I can add elements as I please and imagine a creature with, perhaps, horns growing on its head or big ears. How will your dragon protect itself from the hero who has risked life and limb to slay it?

GRIFFINS

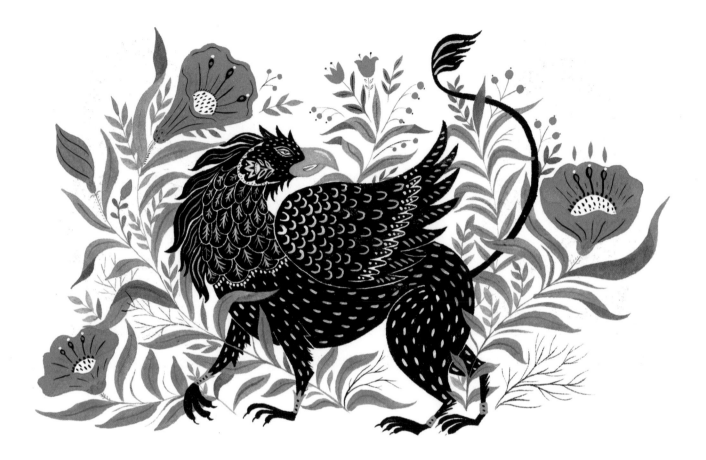

Another large, winged mythical beast is called a griffin, a legendary creature of Greek mythology that is tasked with guarding the king's gold. The griffin has the body, tail, and back legs of a lion, and the head, wings, and front talons of an eagle. Traditionally, the lion was considered the king of beasts and the eagle the king of birds, so combining the two makes for a powerful, majestic creature indeed.

Drawing griffins is not complicated, once you figure out how to draw a lion's body (see page 56). When you sketch mythical creatures, amuse yourself by combining different body parts of different animals. On my griffin, I replaced all four of the lion's paws with eagle claws and added some of the lion's mane to the griffin's head. Stationing the griffin among some vines and colorful flowers lends a touch of gentle charm to his fearsome nature.

After I finished painting the griffin, I decided to transfer the image onto a carving block and create a stamp of this illustration. To do so, you will need to use tracing paper so you don't ruin your original painting. See page 59 for detailed instructions on carving a stamp.

MATRYOSHKAS

 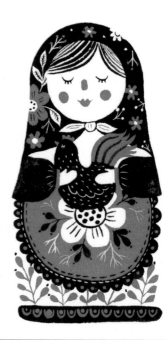

Matryoshkas are traditional wooden nesting dolls from Russia. First made in 1890, they are a set of five or more dolls that can be separated, top from bottom, to reveal successively smaller dolls inside. The last doll is usually a solid piece decorated as a baby. The artistry lies in the intricate painting of each of the figures.

Traditionally, matryoshkas are decorated as peasant girls wearing a headscarf and a summer dress or an apron. Nowadays, modern matryoshkas are painted with fairy-tale characters, caricatures of celebrities and Soviet politicians, animals, and more. The name *matryoshka* is derived from the popular Russian name Matriona, which comes from the Latin for "mother." It is easy to see how this name became associated with the portly matron of a big peasant family whose many children came at regular intervals, represented by the dolls successively revealed inside each other.

To paint a traditional matryoshka, first start with two circles, where the top one is a bit smaller. Connect the circles as shown in the example and draw an inner, smaller circle that will become the matryoshka's face. Decide what kind of headscarf your matryoshka is going to wear, as well as the style of her clothing and her facial expression. I like my matryoshkas to look a bit mischievous, with a knowing, sidelong glance. You can also add little arms and perhaps she could be holding something, such as a household item or a chicken. Traditional outfits are richly decorated with bold flowers and berries and painted in bright colors. You're welcome to experiment with the color palette, but I personally use no more than three colors.

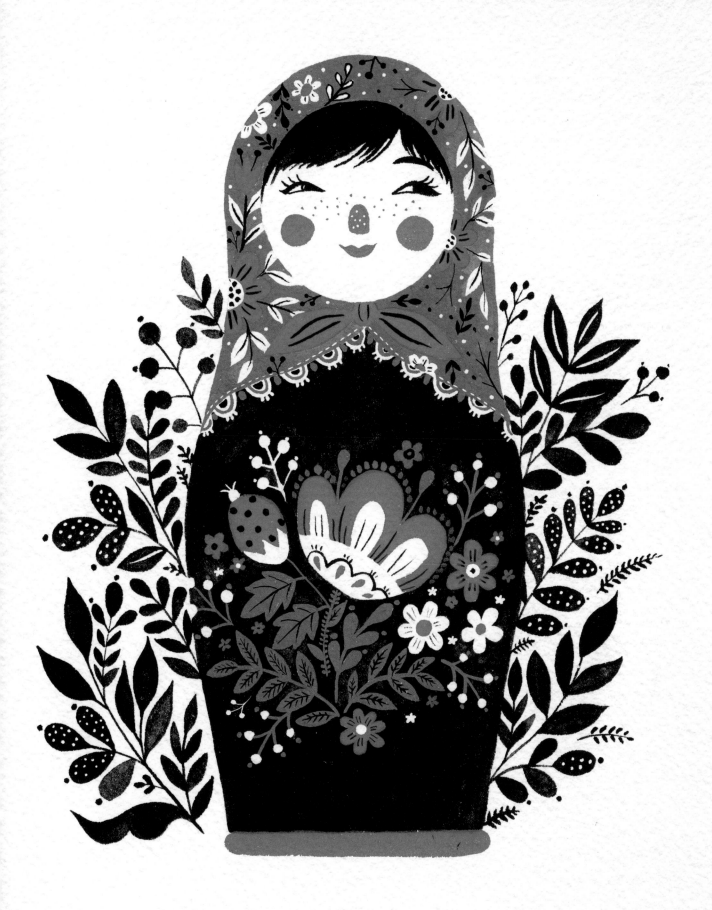

MATRYOSHKAS

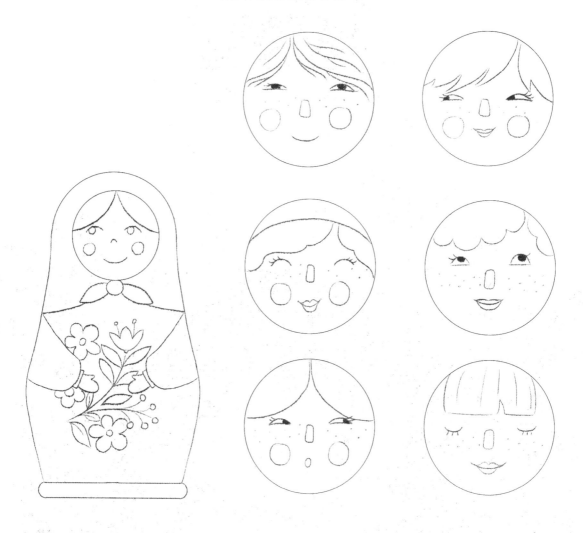

Painting actual wooden matryoshkas is even more enjoyable than painting them on paper. Craft and online stores carry plain wooden matryoshka shapes for you to paint. There are many different silhouettes, so choose what you like.

Another delightful doll to paint is called a *kokeshi*, a traditional Japanese wooden doll. Unlike its Russian cousin the matryoshka, a kokeshi doll does not open up. Traditionally, it is painted with thin, decorative lines and decorated with Japanese flowers. When I

paint my kokeshi, I like giving them the same mischievous faces I draw on my matryoshkas. I keep the outfits fairly simple, as the wooden body is very narrow and does not have much room for larger designs. Kokeshi wooden shapes can also be purchased at craft stores and online.

When painting on wood, I suggest you use acrylics, which will not wash off. You can also cover it with a coat of varnish, but expect the wood to get darker. The more varnish you add, the darker the wood will become.

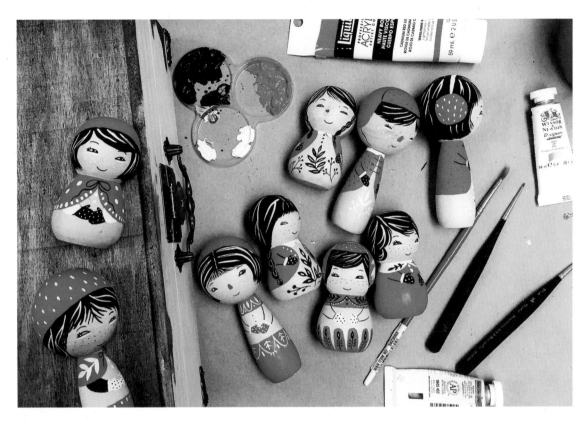

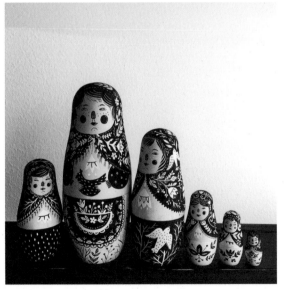

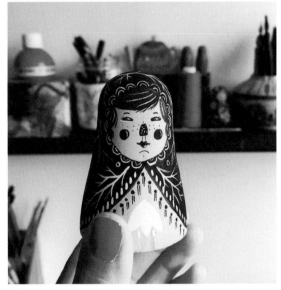

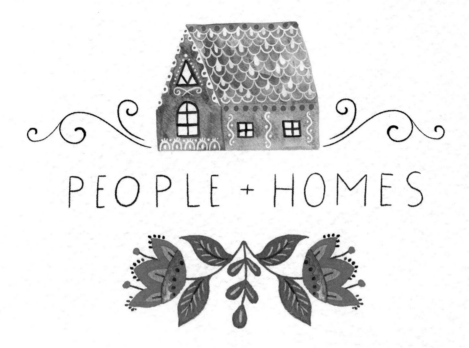

PEOPLE + HOMES

WHEN DRAWING MEN AND WOMEN, I am inspired to clothe them in traditional, colorful, detailed costumes from different nations. Of course, I am inspired by traditional Ukrainian dress, but there's so much out there in the world to excite and enrich you! For children, I like to dress them in playful, innocent clothing with a vintage feel that includes details like pinafores and suspenders. Oh, and don't forget to embellish your people with fun hairdos, facial hair, and accessories!

As with clothing, I like to give my houses lots of elaborate architectural details that are evident on older buildings. I bet there are houses and buildings near where you live that can inspire you with their craftsmanship of yore, so get out, take a walk, and be inspired. I have also included a gingerbread house project for you to draw and then to possibly apply to a real baked house.

Finally, I include a fun exercise for imagining and drawing the household objects that would exist in a house inhabited by a little fairy or mouse, along with ideas for decorating a dollhouse.

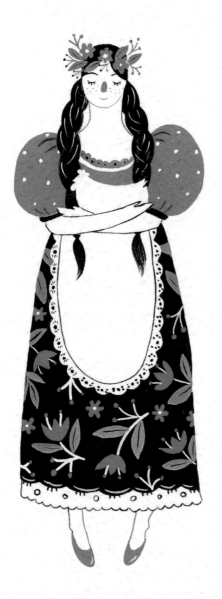

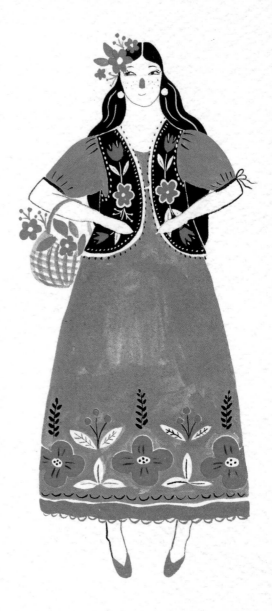

I have always been fascinated with traditional costumes of different nations, particularly the ethnic dress of Russia, Norway, Hungary, Ukraine, Greece, Turkey, Armenia, China, Japan, and, of course, Uzbekistan, where I come from. I love how much attention is paid to the embroidery and other details. Customs and traditions differ from region to region, and each ethnic group has its own identity, so it is impossible to generalize about such a wide and diverse subject as traditional costumes. Suffice it to say that ethnic dress reflects each group's pride in its cultural heritage and in its own recognized forms of beauty.

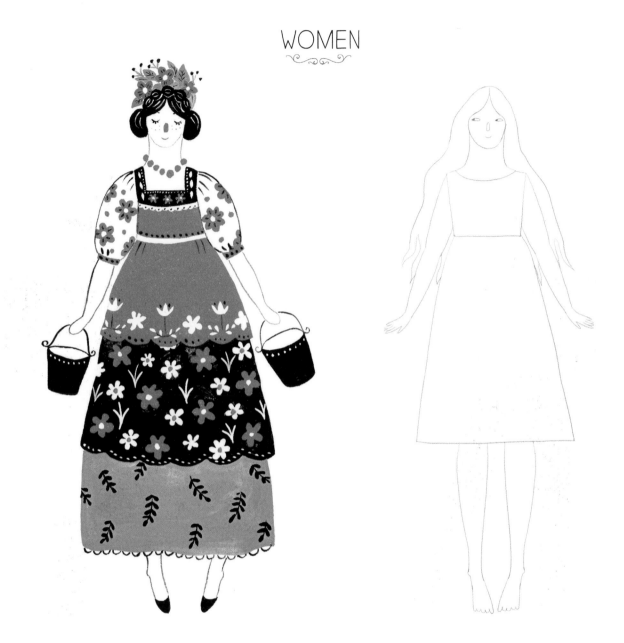

When I draw women, I like to outfit them in beautiful dresses that celebrate such ethnic identity and folk heritage. I like combining layers of colorful patterned dresses, decorated with lace trim and embroidery, detailed vests, and puffy sleeves. For accessories, I like to add bold jewelry and put flowers in their hair. A milk pail or basket of flowers completes the look.

These outfits remind me of the summer dresses that I used to wear as a child and of the gorgeous textiles my mom collected. My love of pattern and clothing were definitely sparked by my mother's custom of sewing dresses for my sister and me. It was exciting to choose a unique design and fabric combination for my future dress. I suppose I am still doing so, only now on paper.

MEN

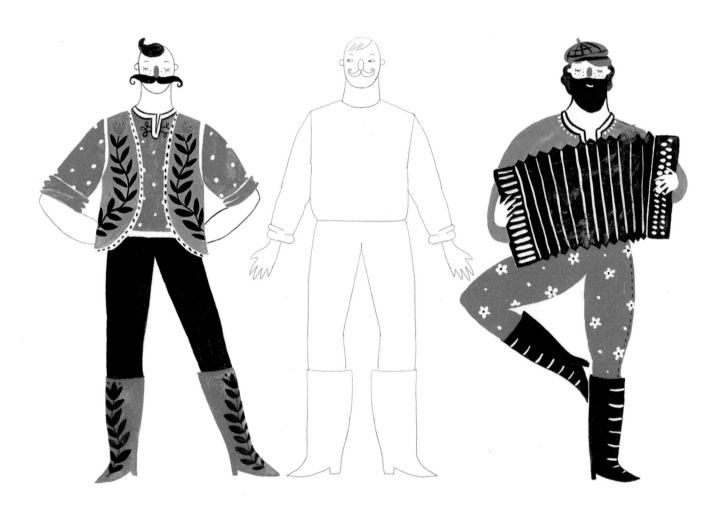

Men's fashion today includes a pair of jeans and a shirt with an amusing quotation, or at least that's what my husband wears every day. But in my illustrations, men are daring enough to wear floral shirts and embroidered vests in bright colors. Their boots are just as festive and as detailed as their clothes. They also wear jaunty caps and style their long, curly mustaches. The men in my illustrations are adept at playing musical instruments, singing jovial ballads about life and love, and dancing traditional folk dances. They remind me of the energetic Russian dancers in *The Nutcracker* ballet.

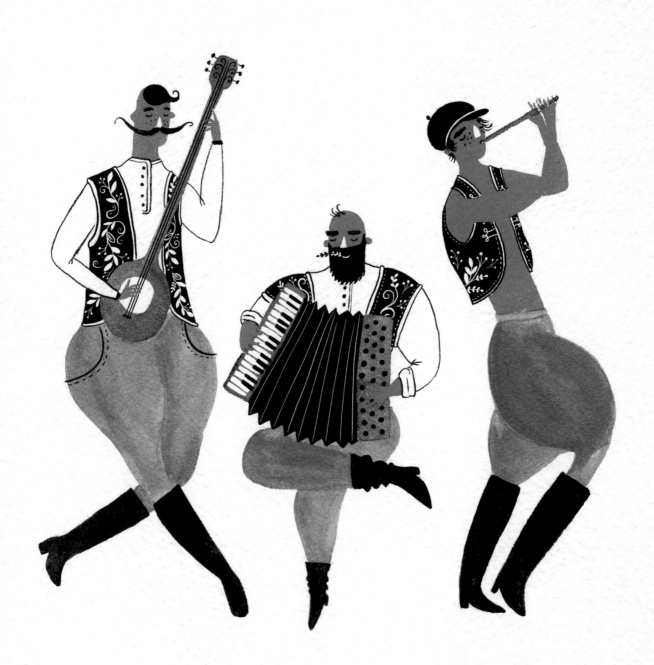

CHILDREN

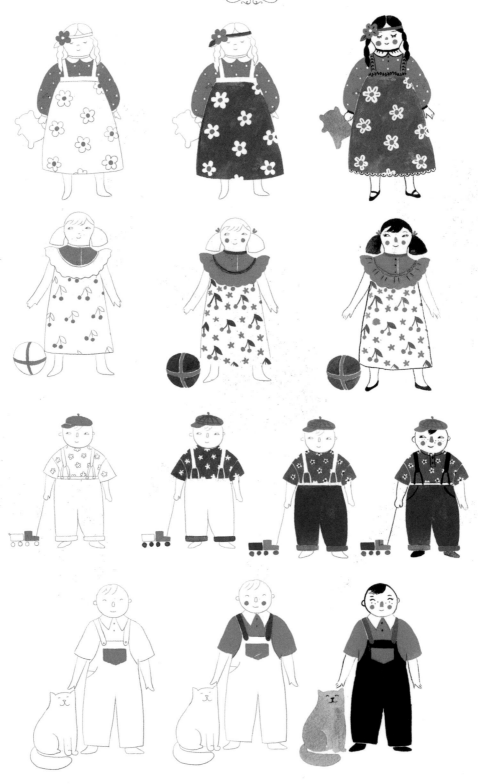

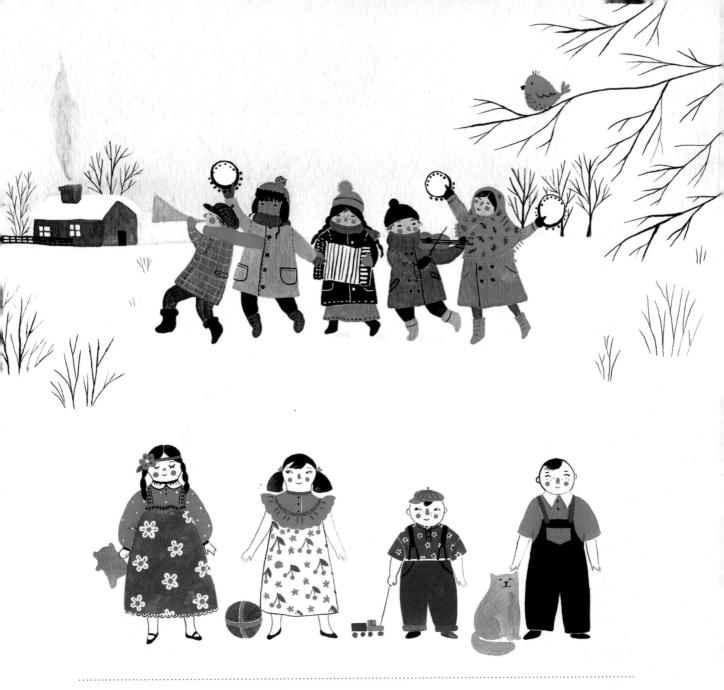

The children in my illustrations are clothed in cute vintage dresses and outfits that I find charming. When I was little, my mom made all of my dresses, and I remember the catalogs of sewing patterns with images of finished garments. I still love seeing girls in puffy dresses and boys in short pants and suspenders. I like to draw clothes that remind me of old-fashioned cutout paper dolls, with their simple contours and flat dimensionality.

To draw children, remember that their body proportions are very different from those of adults. Kids have larger heads and shorter necks, and their arms and legs can be short compared to their body. Their hands tend to be pudgy with little definition. Their eyes are lower on the face and are proportionally very large compared to the face, and the forehead is much broader than it is on an adult.

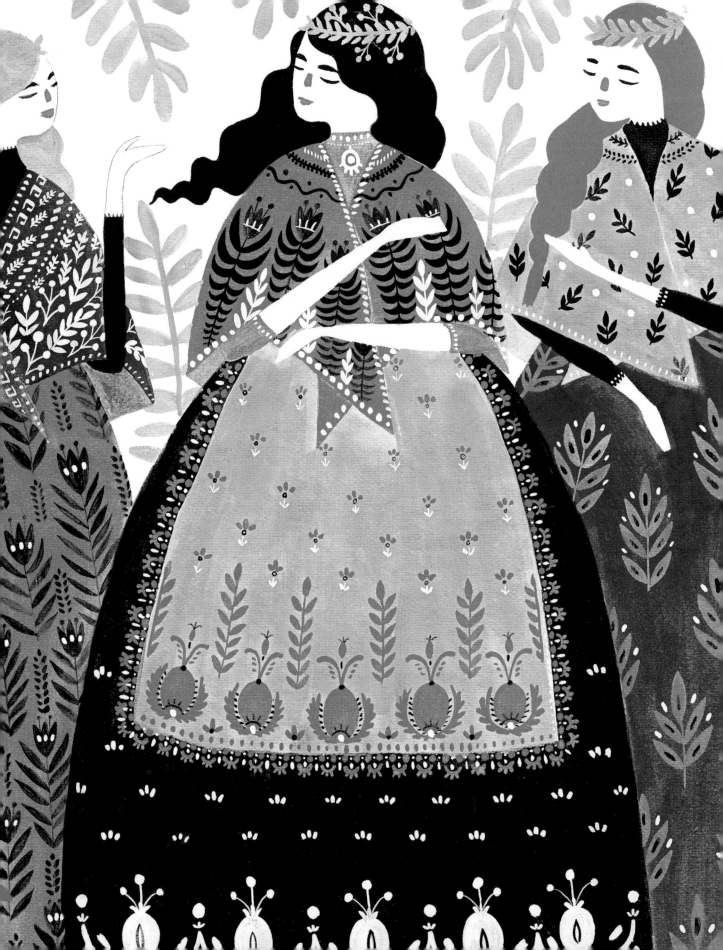

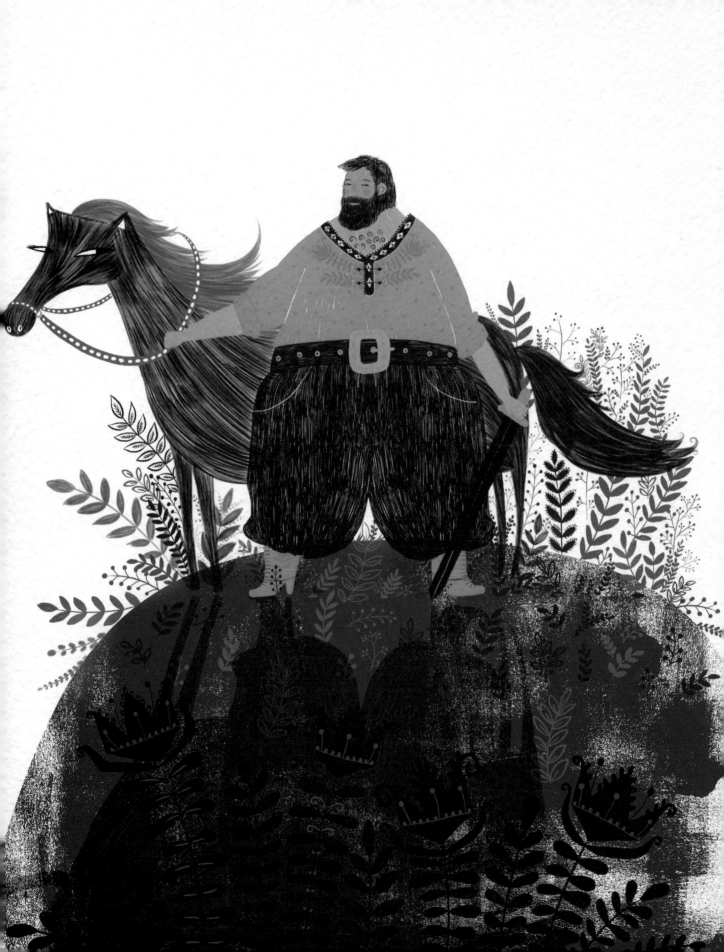

HOUSES

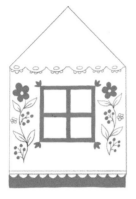 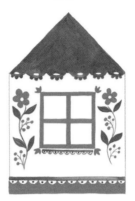 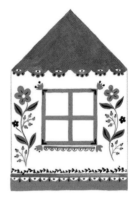

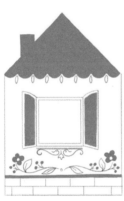 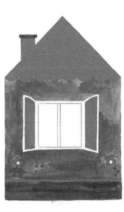 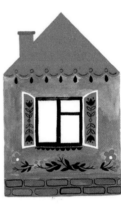

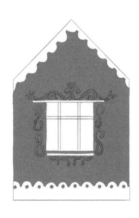 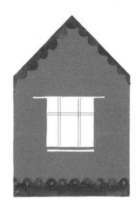

Cozy little houses are so gratifying to draw. The simple shape allows for rich creativity and imagination. Start with a square for the base and a triangle for the roof and your template is ready. Decide how many windows your house will have and choose the roof style for it. Be generous with the decorations and details. I love to paint Victorian-style cottages with folk-art motifs on the walls and elaborate shutters and window treatments. They remind me of the charming cottages in the Uzbekistan countryside.

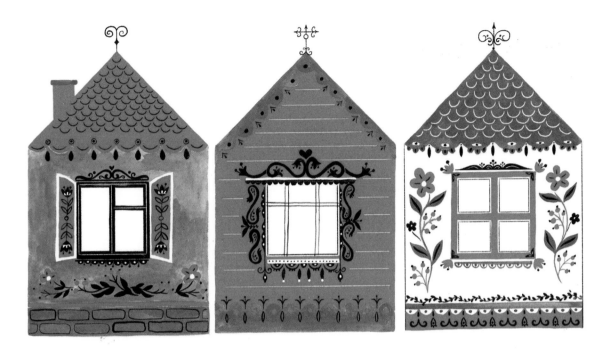

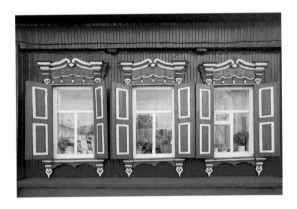

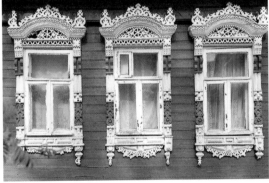

My inspiration for these types of houses comes from my interest in architecture. I always notice decorative elements on buildings whenever I travel. I take pictures as I go, or if I happen to have a sketchbook with me, then I quickly make notes.

In Russia, there's an astonishing window style called *nalichniki*, an intricate wood-carving technique that has been mastered in different Russian regions for centuries. Often, it is combined with decorative painting in various colors. The photographer Ivan Hafizof has archived nalichniki windows, and thanks to his work, we get to see and be inspired by this beautiful style. You can visit the cities of Kazan, Samara, or Tomsk and see it for yourself, or if traveling is not an option, I encourage you to simply go to nalichniki.com and browse through the stunning photographs. Ivan also runs an Instagram account called @nalichniki, where he posts a daily dose of architectural inspiration.

GINGERBREAD HOUSES

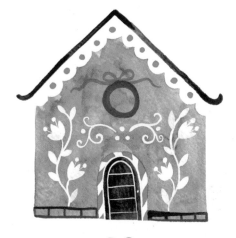

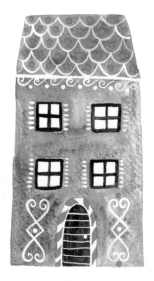

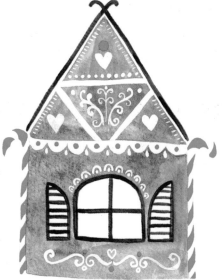

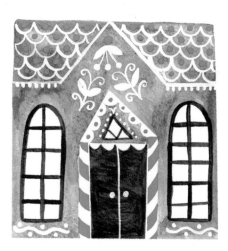

Like many families, we have a tradition of baking and decorating a holiday gingerbread house. Although I claim I'm doing it mostly for my daughter, as she is clearly delighted with all of the sprinkles and icing, deep in my heart, I'm also pleasing my inner child. It gives me such joy to decorate the cute little windows, and my all-time favorite is adorning the roof.

I invite you to explore different styles of gingerbread houses, practice drawing it on paper, and apply your skills to a real baked house. There are an endless number of styles that your house can have. The most common is a Victorian, but an A-frame, Dutch, or Georgian house, among many other styles, would also be wonderful. Yours may vary in shape and construction, but because we are going to assume it is made out of gingerbread, we will paint it brown and decorate it with white. The candy embellishments are up to you.

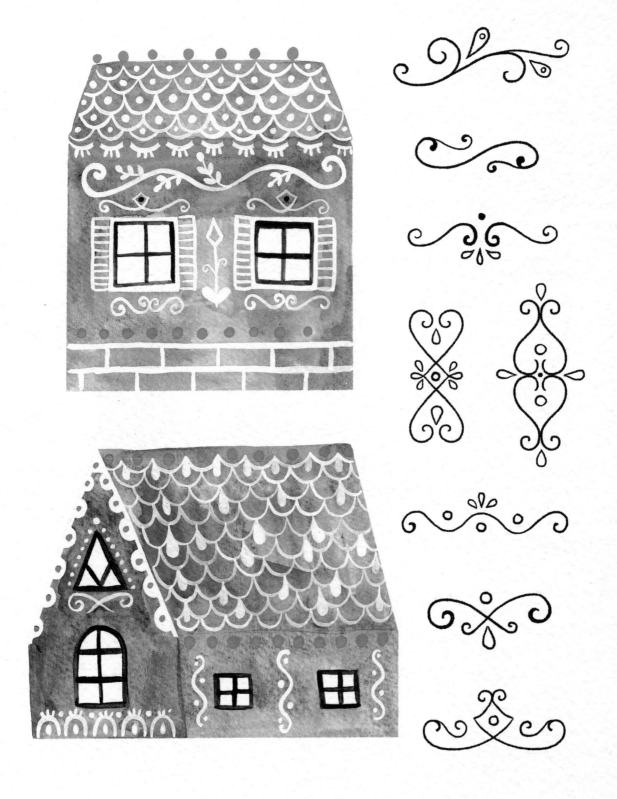

HOUSEHOLD OBJECTS

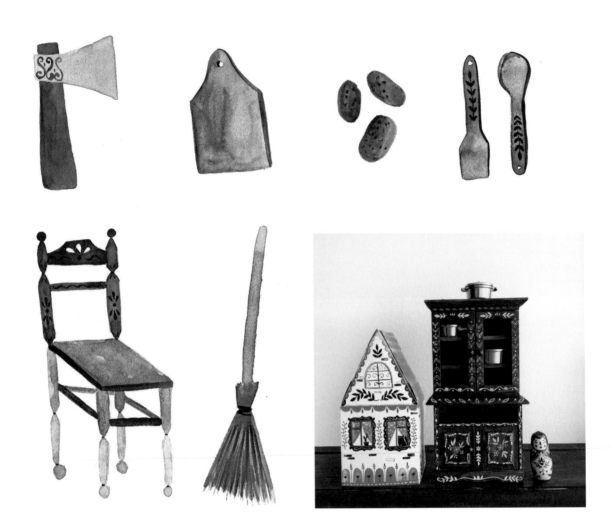

Kitchen utensils and household objects vary from home to home, but many of them will be the same no matter who owns the home and where it is located. But we are not going to draw household objects for just any home: I want you to close your eyes and imagine a house of your fantasy. I want you to do is picture a house inhabited by a little fairy or a mouse. What would it look like? What would be in it?

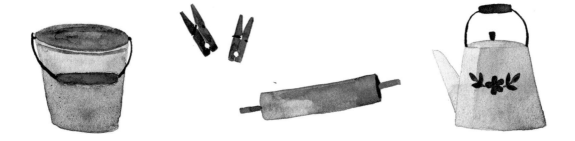

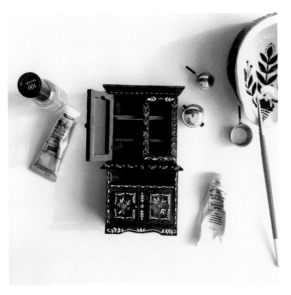

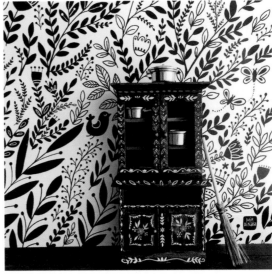

As a little girl, I loved playing with my dollhouse. During my childhood in Uzbekistan, we did not have a lot of toys to choose from, so my friends and I had to make the furniture and household objects for our little inhabitants ourselves. Usually, we used readily available materials like paper, cardboard, and fabric. I still remember a dollhouse I made out of a shoebox as the best there ever was. Luckily, now craft stores are filled with many great raw materials that you can use to create your dollhouse. I like painting my furniture in a style that speaks to me, imagining tiny matryoshka dolls living in the house and using tiny pots and brooms. You can print your own custom wallpaper to decorate the walls, and websites such as Spoonflower will print custom fabric from which you can cut a tiny tablecloth or curtains.

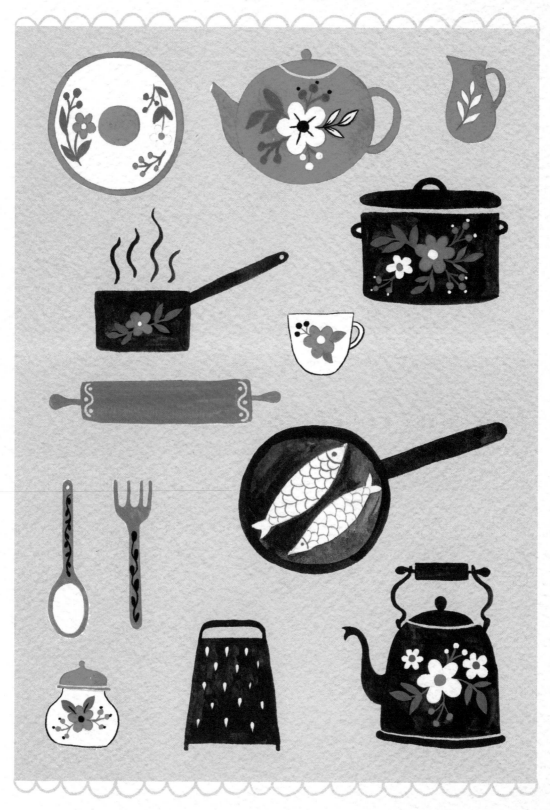

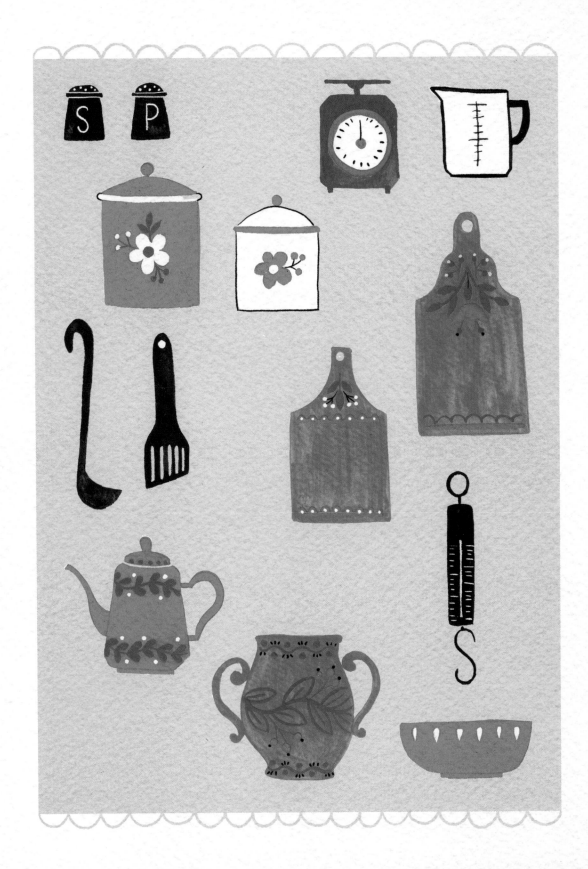

DECORATIVE ELEMENTS + LETTERING

NOW THAT YOU'VE LEARNED how to draw all sorts of animals, people, mythical creatures, and objects in a folk-art style, it's time to apply decorative lettering and patterns to your repertoire. Decorative lettering is an art form in itself, as demonstrated by illuminated manuscripts, and can bring a simple note or drawing to another level.

I have also included a short tutorial in this chapter on how to make a repeating decorative pattern in Photoshop, which can then be applied to printing custom fabric and wallpaper.

Finally, I share some holiday inspiration for drawing hearts for Valentine's Day (and every day) and painting keepsake eggs for Easter.

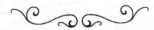

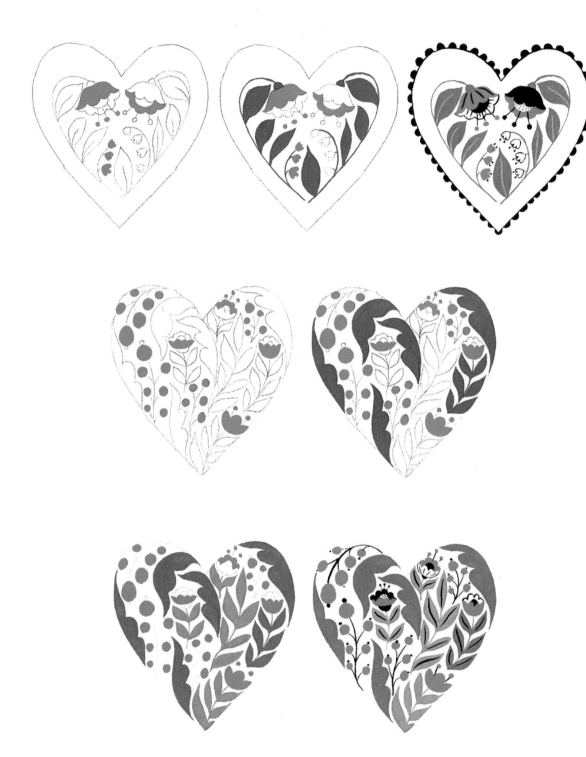

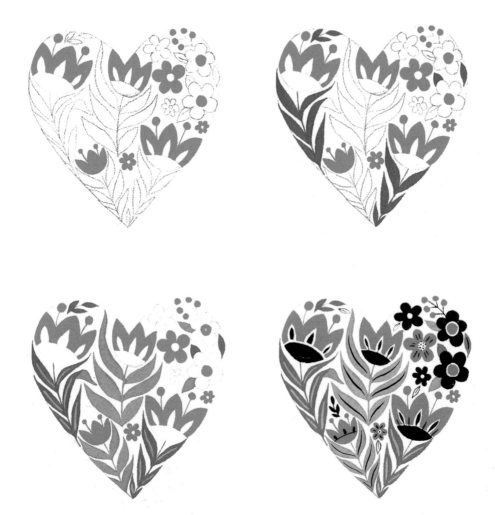

No one knows exactly how the heart came to symbolize romantic love, but theories abound. My favorite is that it resembles an ivy leaf, which was associated with Dionysus, the Greek god of wine and fertility (perhaps the former helps to facilitate the latter).

One thing is clear, though, hearts are not just for Valentine's Day—although my way of creating a heart template might remind you of cutting out valentines for classmates in elementary school. To draw a symmetrical heart shape, I first fold a piece of printer paper in half and sketch one side of the heart, and then cut it out using scissors. This serves as my template. I place that template on my heavyweight watercolor paper and trace around it with a pencil. Now, it's just a matter of imagination as I fill in that heart with designs and patterns. Some of my favorite motifs are flowers and birds, but you can use any other design elements that you might have a heart for.

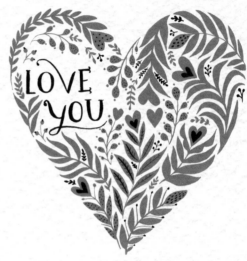

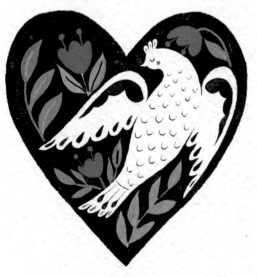

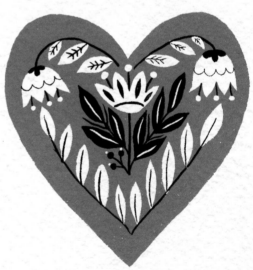

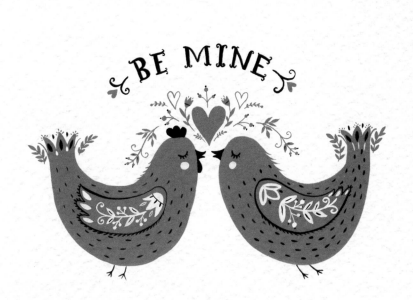

BE MINE

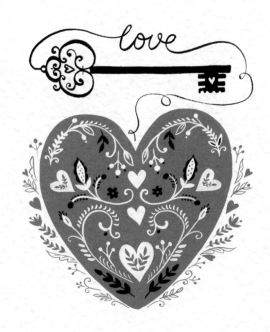

love

PAINTED EGGS

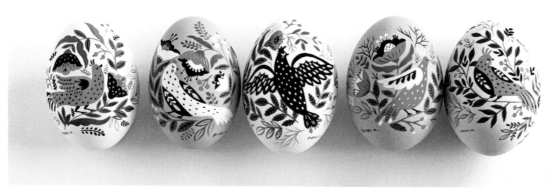

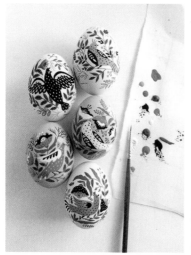

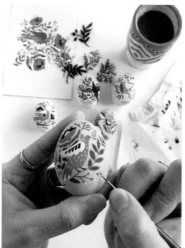

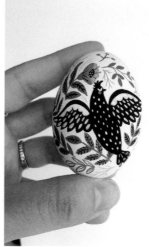

Painting Easter eggs is a beloved tradition that can be traced to early Christians in Mesopotamia, and from there, it spread to Orthodox and Eastern Catholic churches to Russia and then to Europe. The egg represents renewal and rebirth, so it became a symbol for spring and the resurrection of Jesus that marks the Easter season.

My Grandma Lilia enjoyed this traditional Easter craft. She was the queen of Easter, famous for baking the best *kulich* bread and for painting gorgeously decorated eggs. Watching her, I grew to love this delicate artistry as well.

To preserve the painting and keep an Easter egg as a souvenir for years to come, I buy plain white and beige porcelain eggs from a local craft store. They are uncoated and look very real. You can also buy wooden eggs, which are fun to paint and give as gifts. I start with a light pencil sketch to map out what I'm going to draw. This year, I drew five different birds, shown in the photos here. After I'm done sketching, I proceed with the paint. I use acrylic paint because it will not wash off or fade over time. Acrylics are pretty opaque, so it's safe to layer colors as you progress with your design. I usually don't cover the eggs with varnish because I like the rough and uncoated look of them, as they're a decoration that will mostly be placed on a shelf and not touched often. However, you can add a layer of varnish for protection, if you prefer.

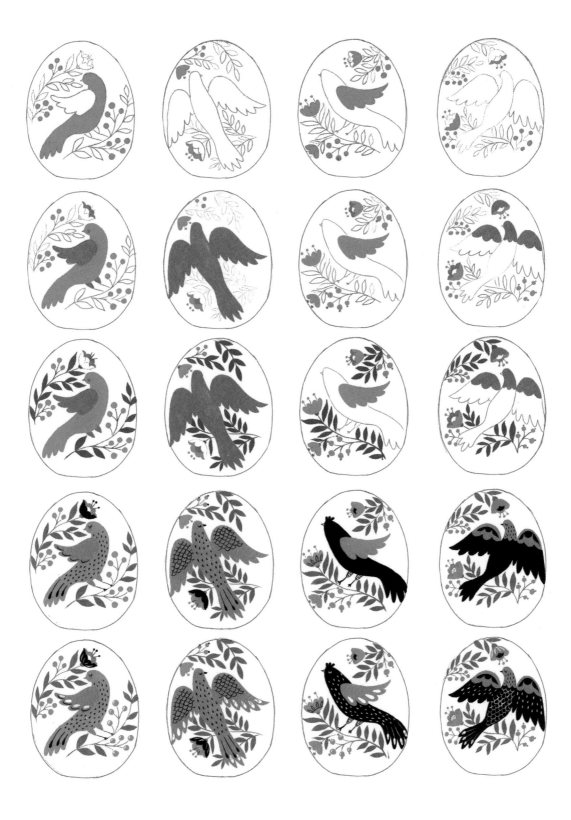

LETTERING

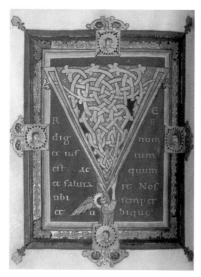
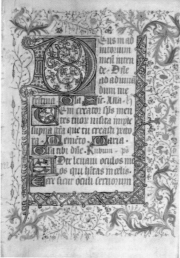
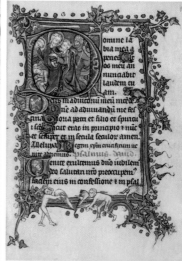

I enjoy decorative letters as a traditional art form. Such letters were an important part of the illuminated manuscripts that monastic scribes created for special display books, especially the Bible and important texts of late antiquity. Perhaps the most famous illuminated manuscript is the Irish *Book of Kells*, thought to have been made around the year 800AD. Decorative letters emphasize the first initial at the beginning of a new section of text or a special passage in a manuscript. Classically, these letters were decorated with interlaced foliage and vines, as well as human beings, animals, and mythical beasts. Nowadays, decorative letters are used on stationery, as a decoration for nurseries celebrating the name of a newborn child, on certificates, and in picture books.

I like when the letter shapes are not too rigid but rather have a sense of dancing on the page. I find such free-form calligraphy charming. You can start by sketching out the letters with a pencil, adding swooshes, and exaggerating the forms as you please. I use a tiny, size 000 brush for adding intricate embellishments that make the letters sing.

A B C D E
F G H I J
K L M N
O P Q R
S T U V
W X Y Z

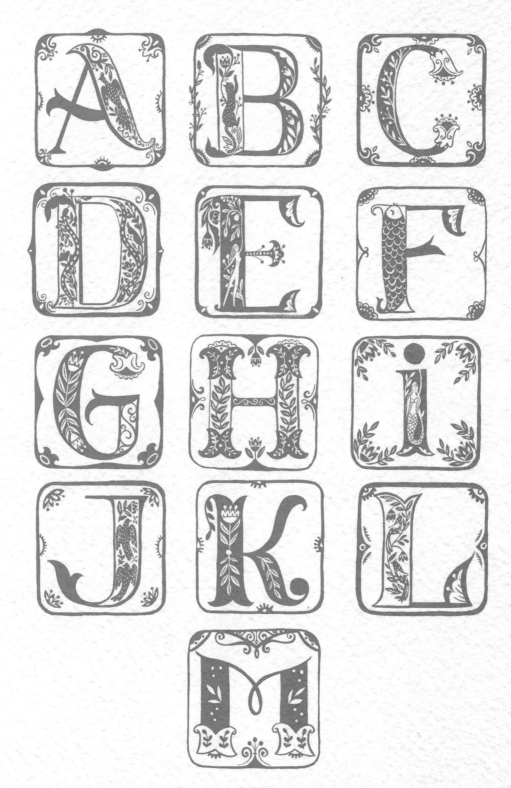

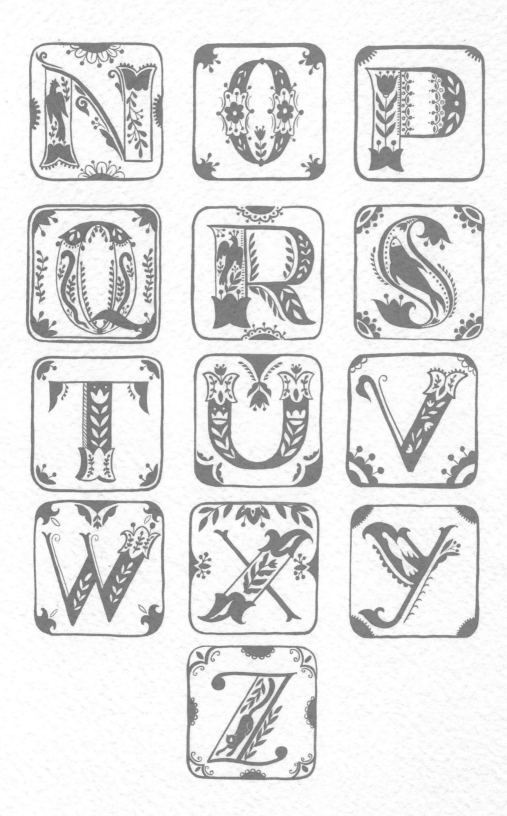

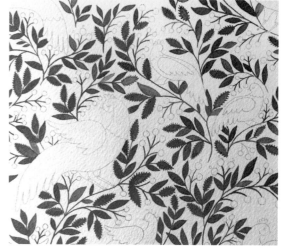

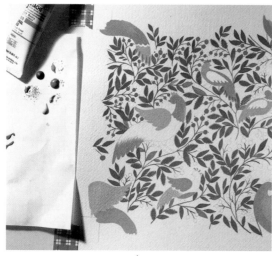

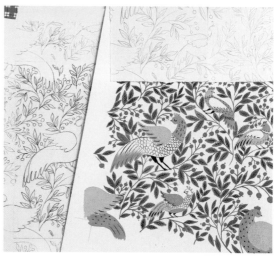

Sometimes it's nice to get away from representational art and just draw a pattern. To create a repeat pattern, you need to learn how to make a repeat tile. Using your ruler, draw a square or a rectangle. It's important to make sure your lines are precise and parallel, because the left side of the tile has to match up to the right side of the tile, and the top of the tile has to match up to the bottom of the tile. It's okay if your art falls outside the boxed lines because you are going to import it into Photoshop and make a precise cut. Then you can duplicate the tile and line it up in rows and columns to make a repeating pattern.

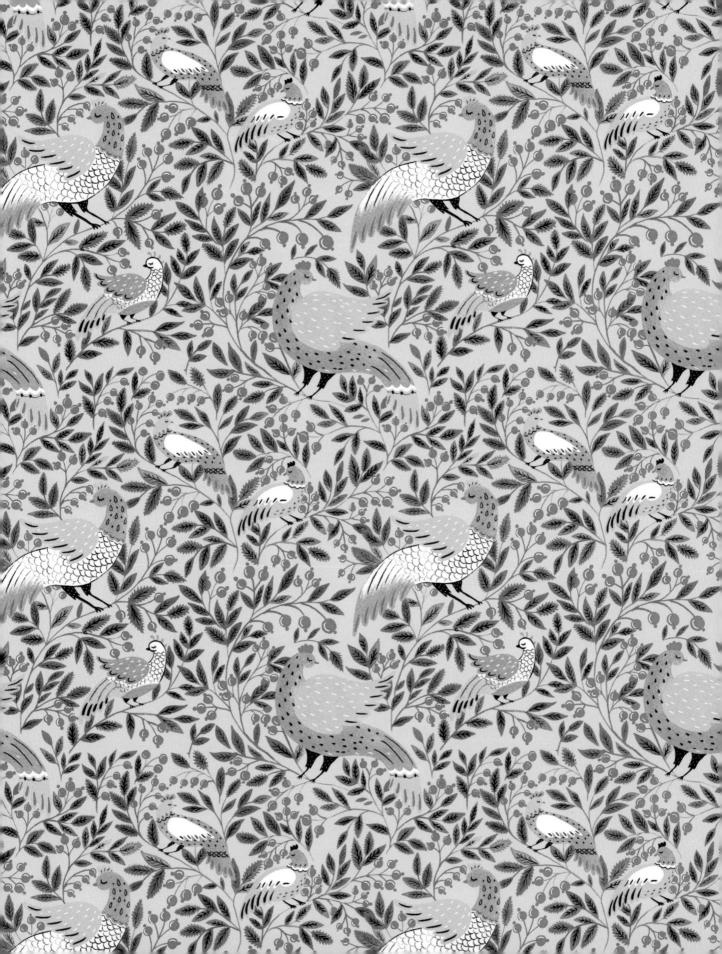

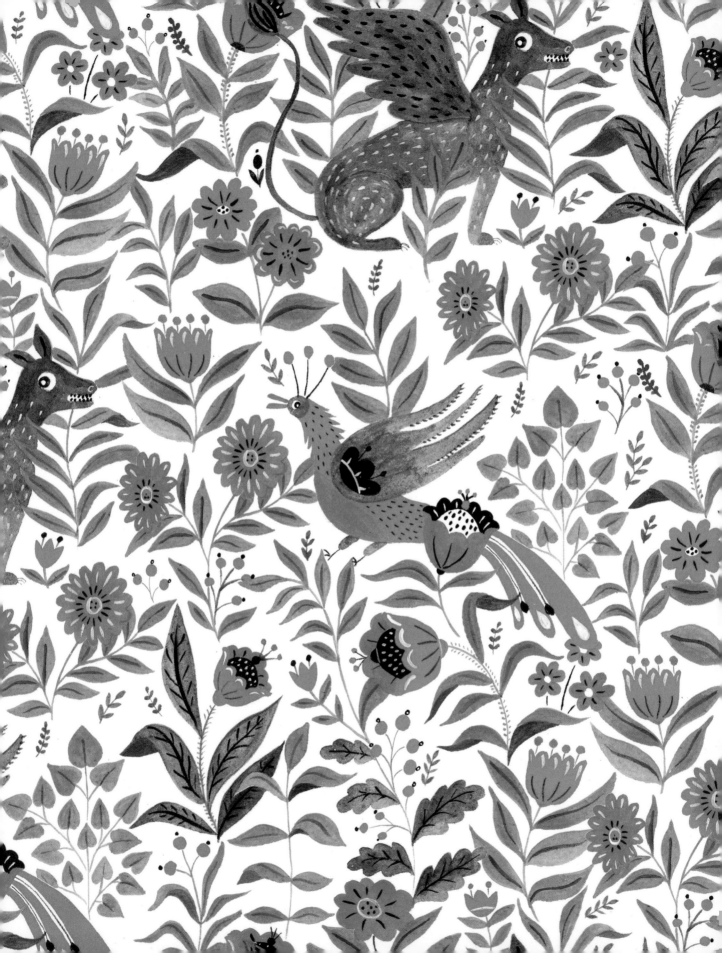

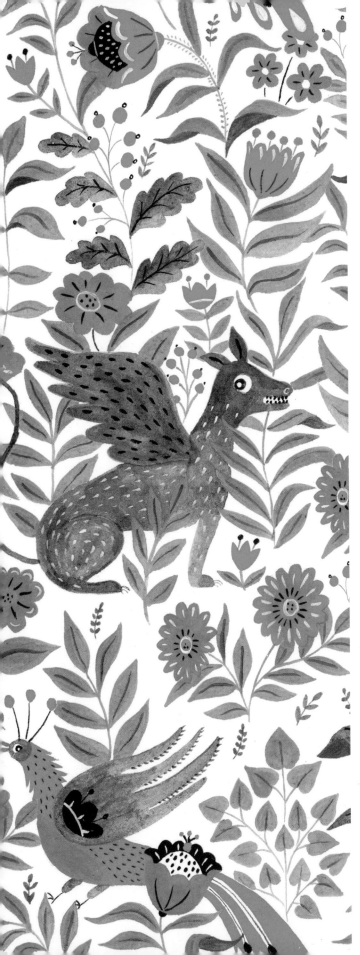

PATTERNS

If designing patterns is your true passion and you plan to make a lot of them, I suggest investing in a nice light box because it will make your sketching and tracing process so much easier. There are many brands out there; I personally prefer using the Huion LED Light Pad Model A3. If you don't want to invest in a light box or are creating repeat patterns just for fun, you can simply tape your sketch to a sunny window and trace around it.

For me, it usually takes about three rounds of sketching to create a pattern I am happy with. My first sketch is very rough and I use it to map out the main elements. Then, I trace it into a nicer, cleaner tile and scan it into Photoshop, where I tile it up to get a feel for the rhythm. As with music, repeating patterns have a cadence all their own.

See my additional sample patterns on the following pages.

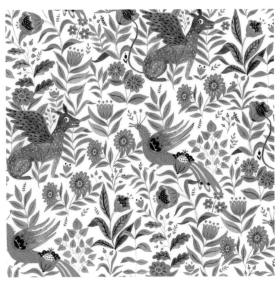

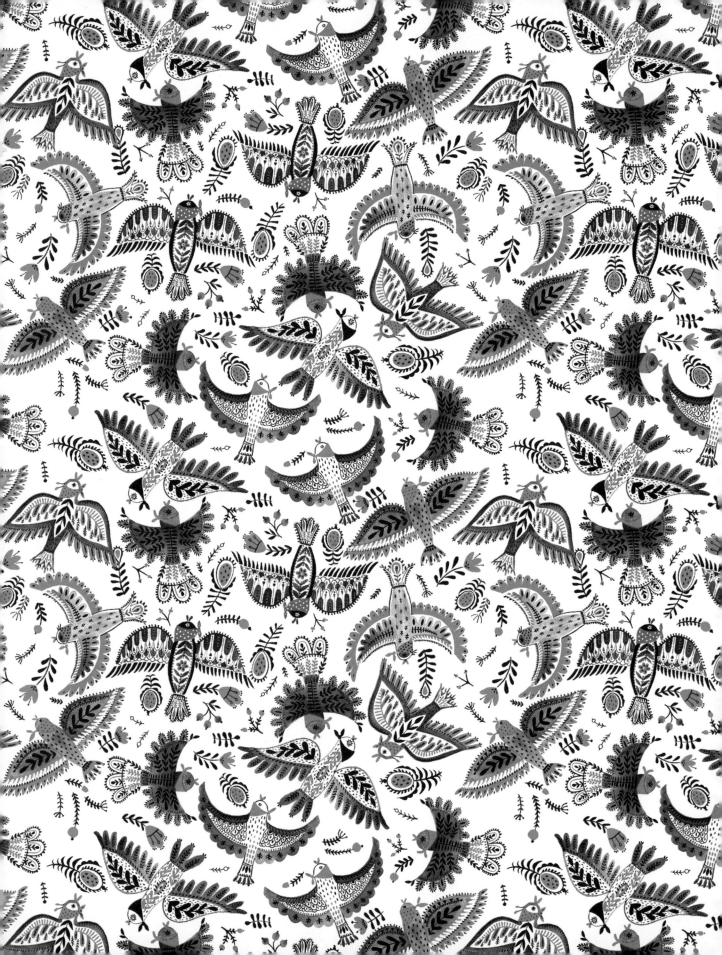

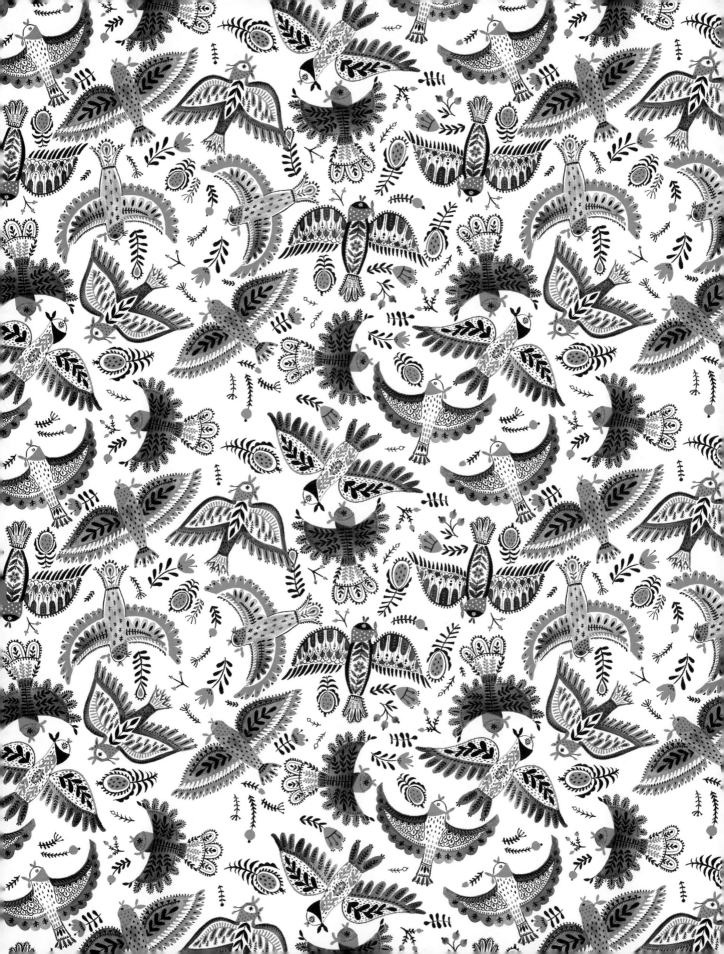

PROJECT IDEAS

IN MY SPARE TIME, I love practicing different techniques such as printmaking, silk-screening, working with clay, and painting on different surfaces, like wood, textiles, and walls. These techniques give my artwork so much dimension and functionality. I also find joy in crafting one-of-a-kind items that will be treasured forever. If you need some ideas for these types of projects, I encourage you to think about what excites you. For example, there was a time when I was obsessed with restoring old chairs by stripping off the old paint to reveal the raw wood and then decorating the chairs with paintings of flowers and leaves. If working with big furniture intimidates you, you can search for smaller wooden objects—an old jewelry box, cutting board, spoons, or anything else. I like searching for these items at flea markets and antique stores, because they already have so much character. Another idea is to play with printmaking. If you don't have access to a silk-screening facility, carving a rubber stamp is so much fun! By mastering this technique, you can create your own unique textiles, T-shirts, or address stamps. Whichever technique and surface you choose, don't forget to practice a few times before working on your final piece, and simply take your time, be patient, and enjoy the process. It's a lot of fun!

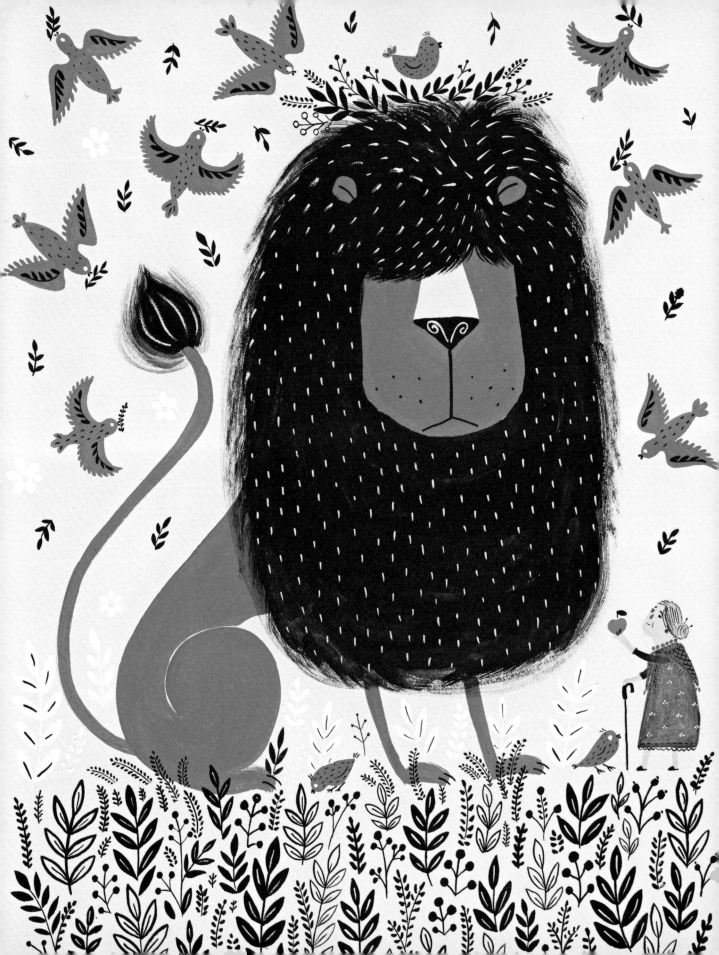

HOW TO MAKE A STAMP

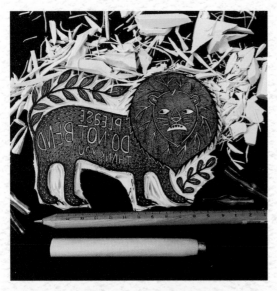

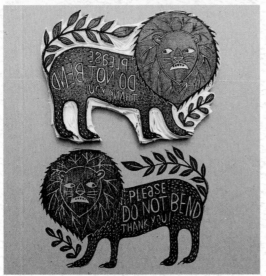

A lion's body shape is also very easy to carve into rubber or linoleum to make a print or stamp. I prefer using Speedball carving rubber because it is very soft and easy to engrave. You can find it at your local craft store or online.

Start with drawing a pencil silhouette on paper. Press the rubber against the paper and the graphite from the pencil will transfer onto the rubber. I usually start with carving the outer shape first before moving on to the inner details. Remember, you will be carving out the negative space, leaving the image area raised; this area will be covered in ink after you're done making your stamp. If you choose to add words to your stamp—in my example, I wrote, "Please do not bend, thank you"—then you need to make sure that you transfer the mirror image onto the rubber; otherwise, the words will print backward on paper.

After you have carved the outer shape of your lion, it's time to move on to intricate details on the lion's face. To make this job easier, I carve a single line indicating the lion's face and add a few lines in his mane to suggest fur. If you find carving out his eyes difficult, then carve dreamy, closed eyes instead.

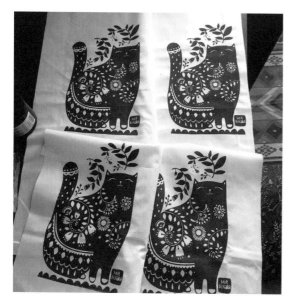

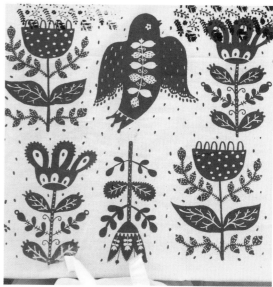

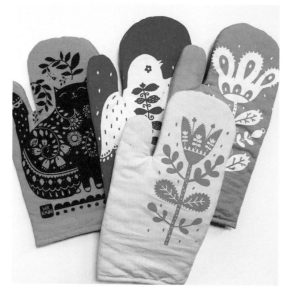

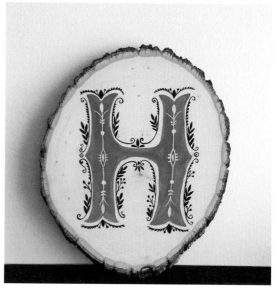

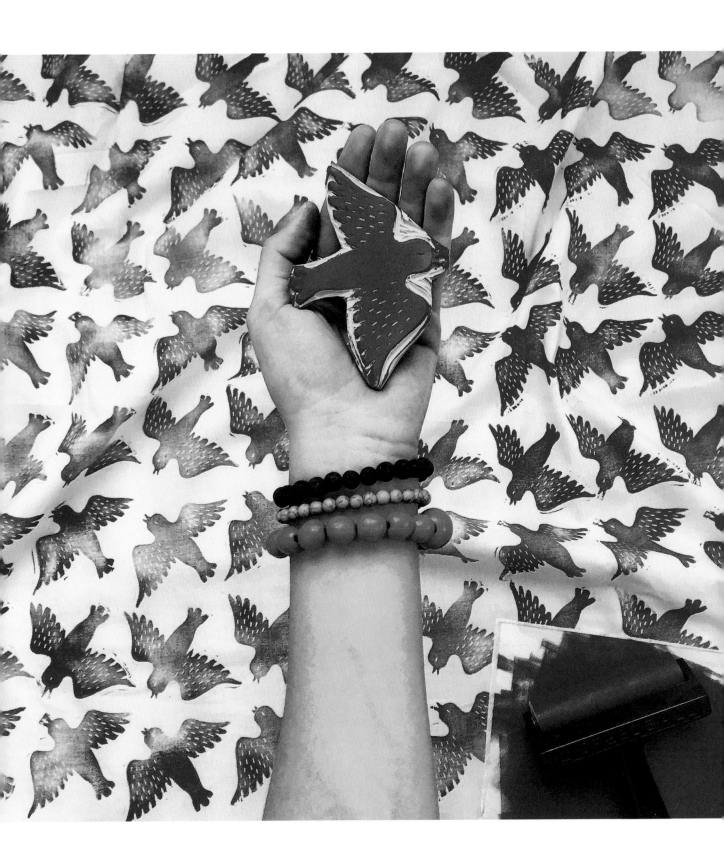

PROJECT IDEAS

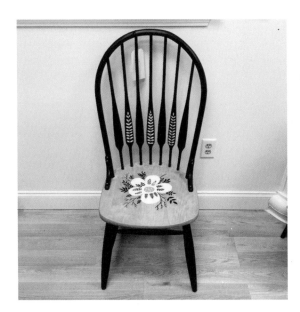

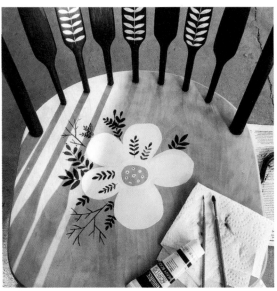

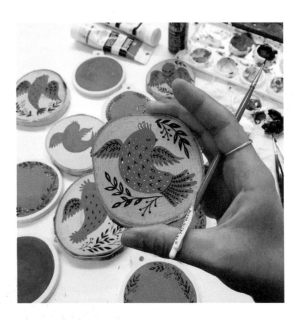

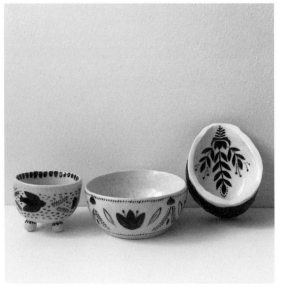

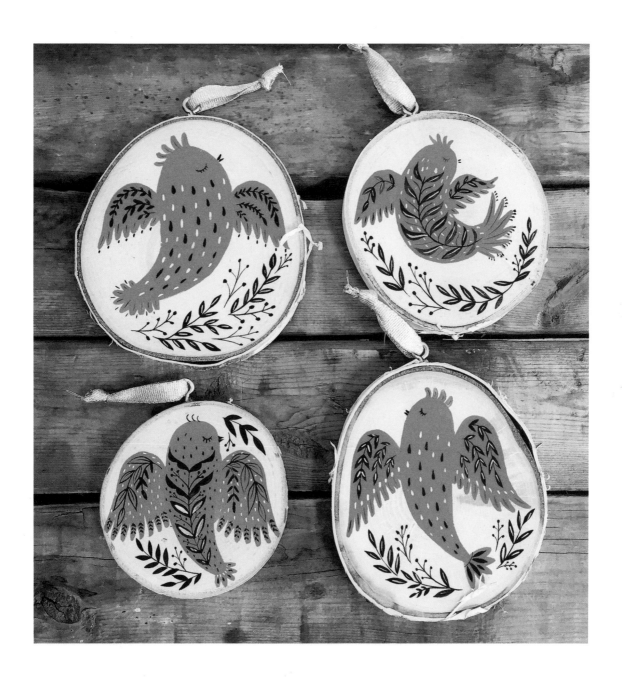

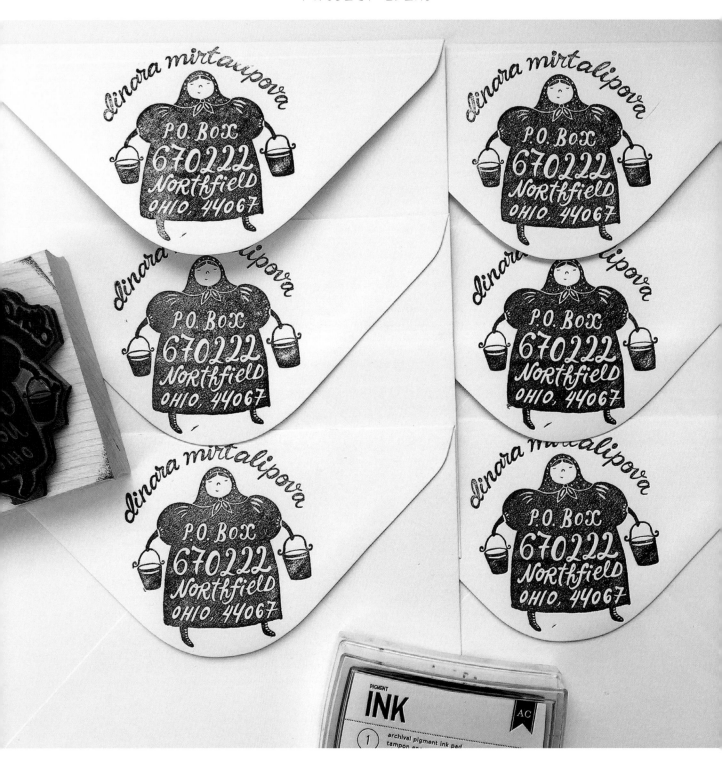

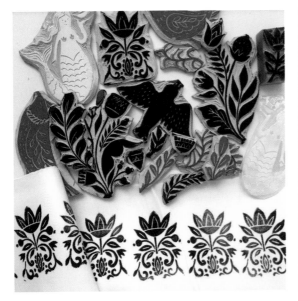

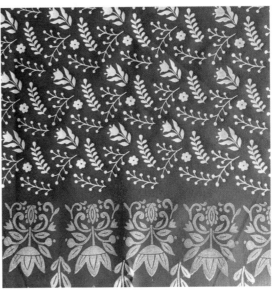

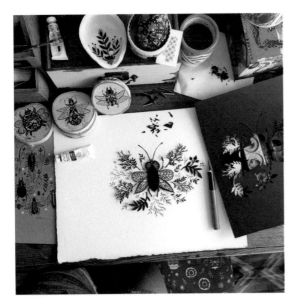

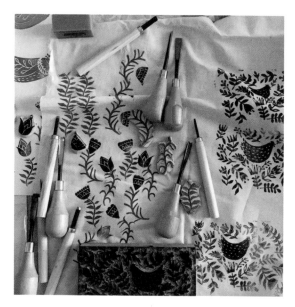

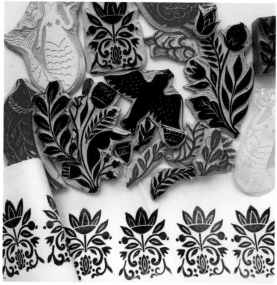

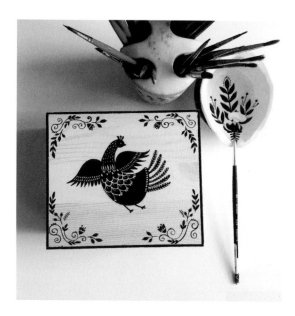

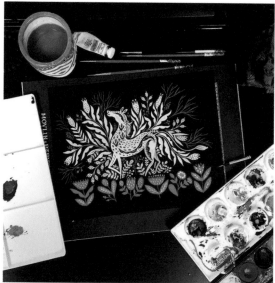

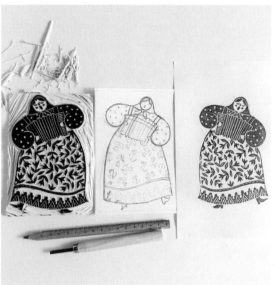

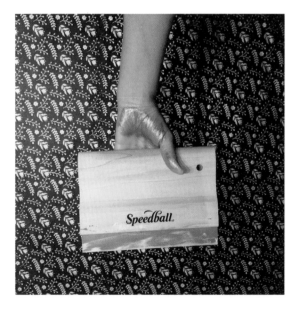

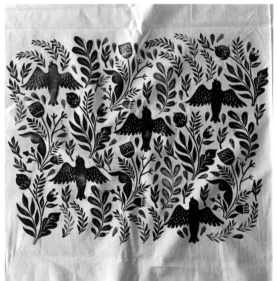

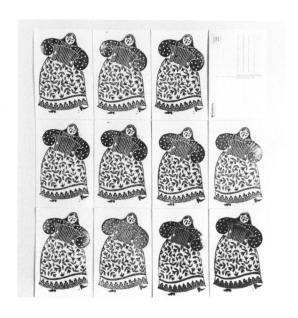

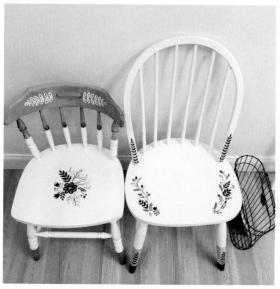

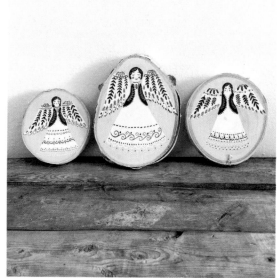

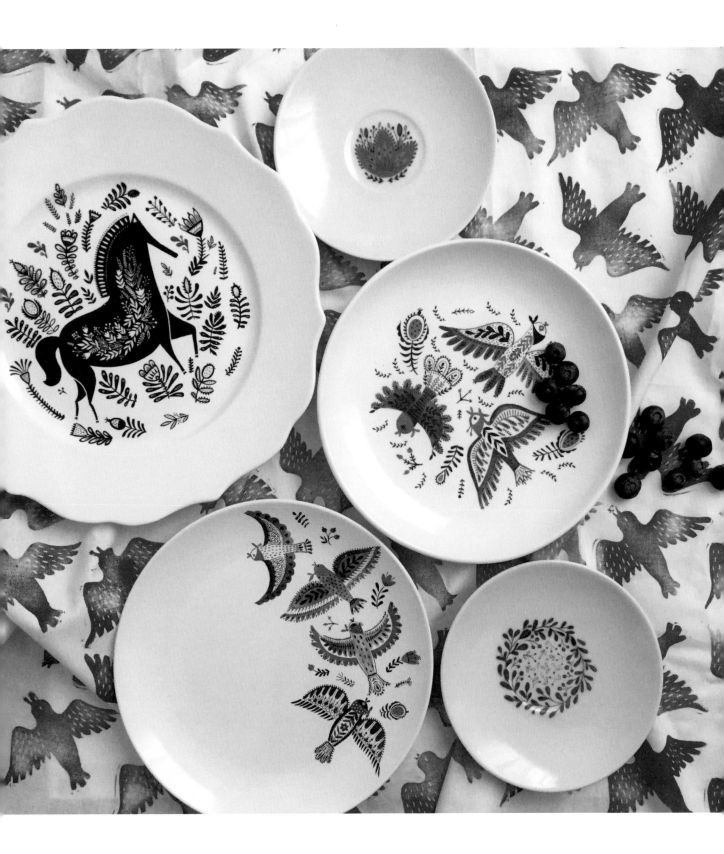

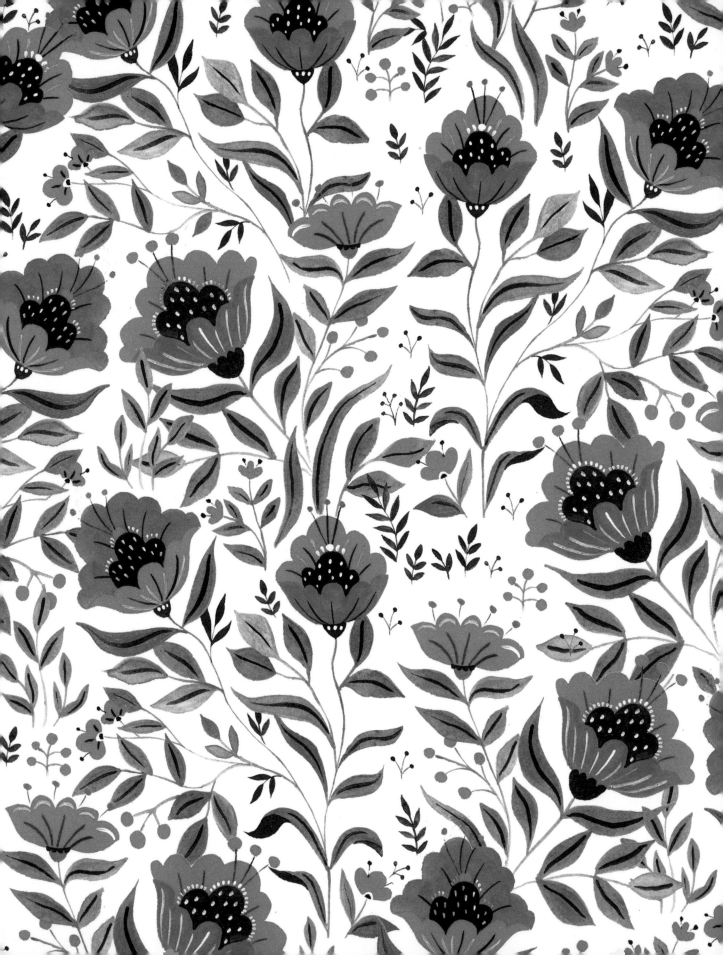

‿ᯓ ACKNOWLEDGMENTS ᖶ‿

I WANT TO THANK Sarah Eklund, who changed my life; Dan Weiss and Greg Hyland, who first hired me and gave me a chance at American Greetings; and Martha Ericson, Lynn Shlonsky, and Salli Swindell, for being important mentors. My thanks also go to my art rep, Chrystal Falcioni, and the group Magnet Reps. I'm thankful for being born into a great Uzbek-Russian culture, where I absorbed the traditions and folklore. And I'm also thankful to the United States of America, which welcomes immigrants and treats them with respect, providing equal opportunities for growth and development.

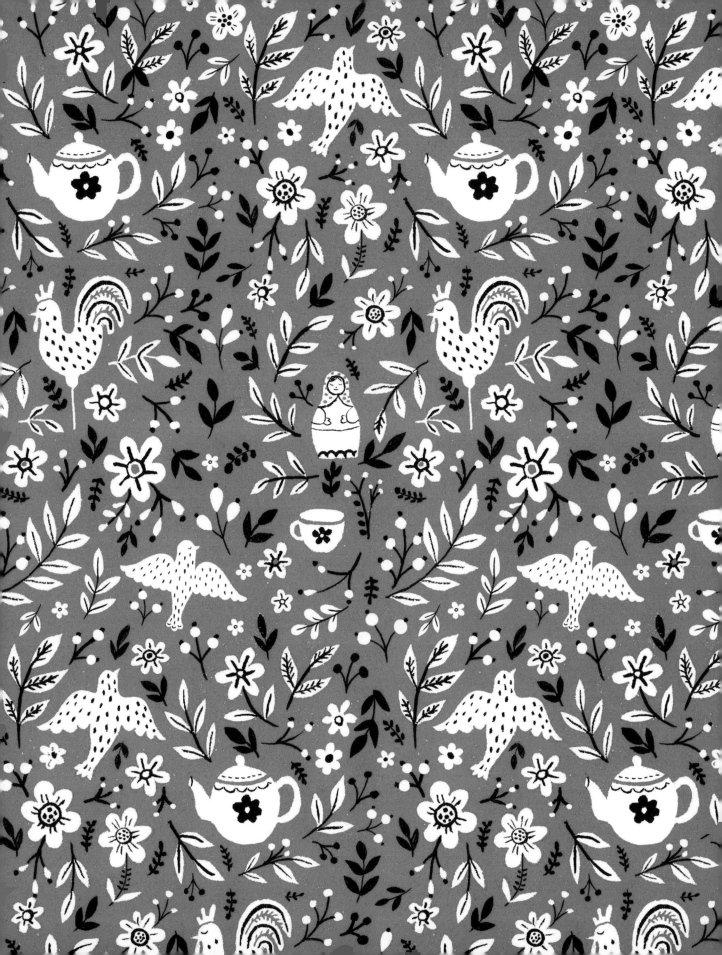

✍ ABOUT THE AUTHOR ✍

DINARA MIRTALIPOVA is a self-taught illustrator and designer. Born and raised in Tashkent, Uzbekistan, she eventually landed in snowy Ohio. Dinara studied computer science at the Tashkent State University of Economics; however her true passion was always patterns and illustration. Raised in Soviet Uzbek culture, Dinara inhabited Uzbek-Russian folklore that still influences her work.

For a long time Dinara has been among illustrators and designers at American Greetings. She left her creative role at AG in February 2014 to pursue her ever growing freelance career and to start a new change as a free-spirited independent designer.

↝ NOTE FROM THE AUTHOR ↜

INSPIRATION IS SUCH A MAGICAL FORCE. It lives by its own rules and comes and goes as it pleases. Sometimes it comes to me when I'm in bed, tired after a long day. I close my eyes anticipating that I will fall asleep in a few moments and—Boom!—I have a vision, an idea, an inspiration. So there are nights when I get up from bed and sketch until I capture that vision. And then there are days when I'm waiting and waiting for the inspiration to hit me—and nothing.

It's very easy these days to simply go on Pinterest in a search of artists to be inspired by. But at the end of the day, it's their inspiration that gets transferred onto your paper, not yours. To find yours, here's what you need TO NOT do:

• Search for art on style-driven websites.
• Look through trendy and cool magazines and publications.
• Go to gorgeously decorated stores.

And this is what you need TO do:
• Find that music that pleases your soul.
• Watch that movie you love for the 1,000,000th time.
• Read picture books from when you were little.
• Close your eyes and try to remember the textiles from your childhood.
• Imagine your favorite characters.
• And, finally, close your eyes and visualize what makes you happy and what makes you authentic. You are so much bigger than mimicking someone else's work or style.

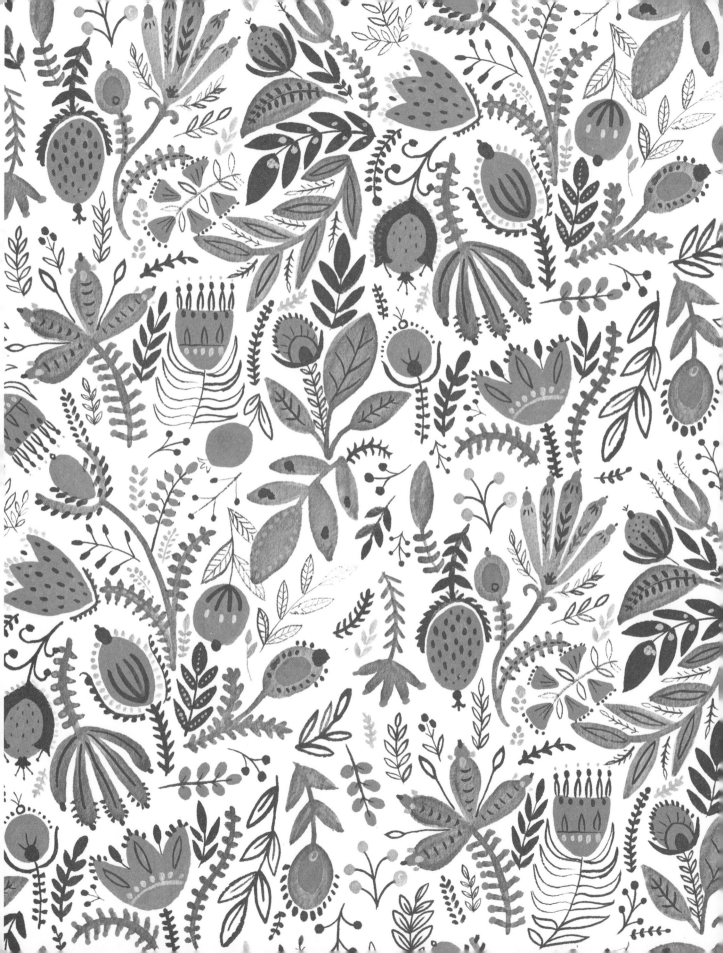

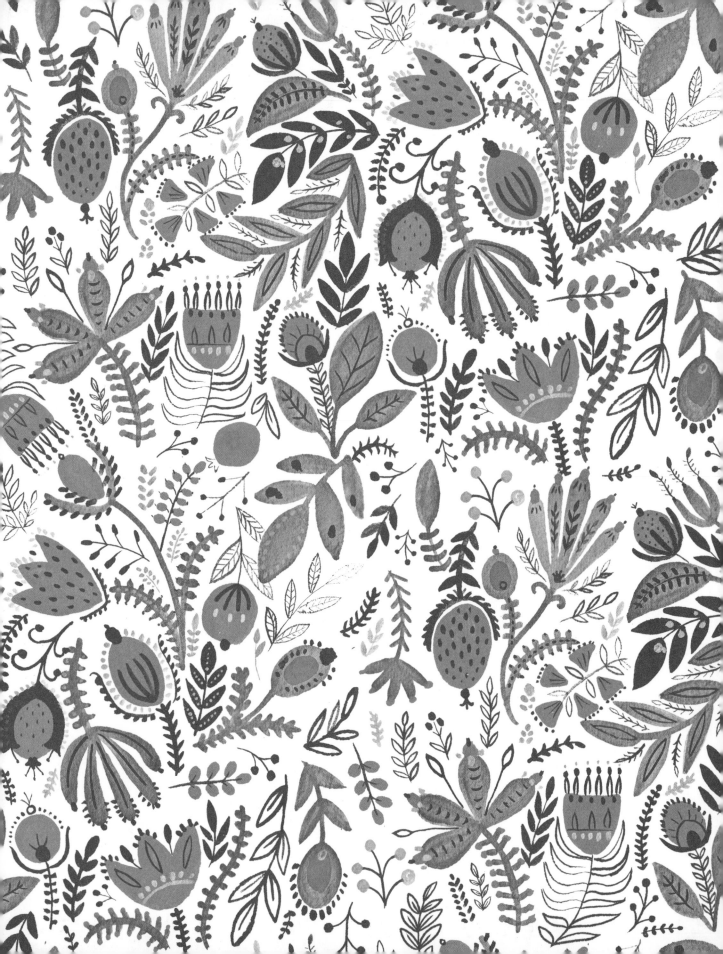